WATERCOLOR 101

Techniques for the Absolute Beginner

Jeanette Robertson

Sterling Publishing Co., Inc.
New York

Designed by Susan Fazekas
All watercolor art by the author

Library of Congress Cataloging-in-Publication Data

Robertson, Jeanette, 1950 Oct. 15–
 Watercolor 101 : techniques for the absolute beginner / Jeanette Robertson.
 p. cm.
 Includes index.
 ISBN-13: 978-1-4027-2352-0
 ISBN-10: 1-4027-2352-0
 1. Watercolor painting—Technique. I. Title. II. Title: Watercolor one 'o' one. III. Title:
Watercolor one hundred one.

ND2420.R62 2007
751.42'2—dc22 2006029561

10 9 8 7 6 5 4 3 2 1

Published by Sterling Publishing Co., Inc.
387 Park Avenue South, New York, NY 10016
©2007 by Jeanette Robertson
Distributed in Canada by Sterling Publishing
c/o Canadian Manda Group, 165 Dufferin Street
Toronto, Ontario, Canada M6K 3H6
Distributed in the United Kingdom by GMC Distribution Services
Castle Place, 166 High Street, Lewes, East Sussex, England BN7 1XU
Distributed in Australia by Capricorn Link (Australia) Pty. Ltd.
P.O. Box 704, Windsor, NSW 2756, Australia

Printed in China

Sterling ISBN-13: 978-1-4027-2352-0
 ISBN-10: 1-4027-2352-0

For information about custom editions, special sales, premium and
corporate purchases, please contact Sterling Special Sales Department
at 800-805-5489 or specialsales@sterlingpub.com.

This book
is dedicated
to all my students.

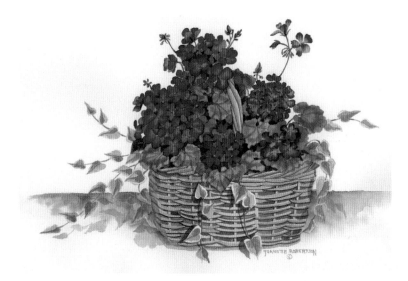

Contents

Acknowledgments

would like to acknowledge Martha on Cape Cod;
Downeast Concepts, Inc.; Castello di Montegufoni,
www.montegufoni.it; my editor, Jeanette Green;
Cazenovia Library; Manlius Library; Manlius Adult Ed;
Cazenovia Adult Ed; SUNY Morrisville Adult Ed; Syracuse
University College; YMCA Fayetteville, NY; Cazenovia
Watercolor Society; and my friends Martha, Nicki, and Toloa
for proofreading the manuscript.

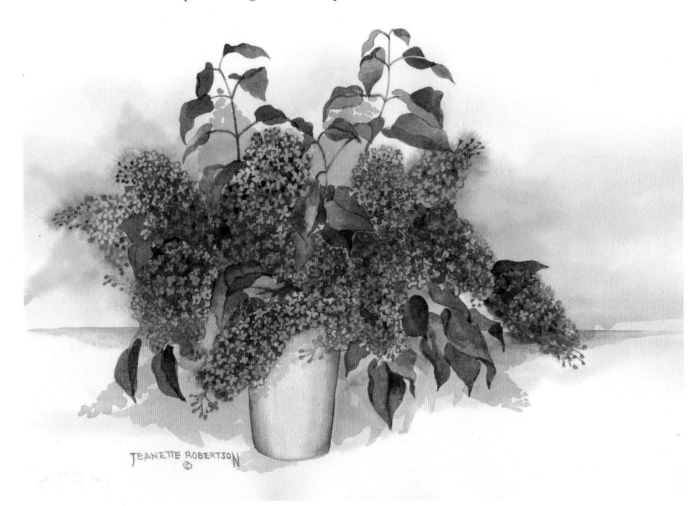

JEANETTE ROBERTSON

Introduction

This book consists of exercises, step-by-step demonstrations, and critiques that will prepare the beginner for painting in watercolor. Designed for the aspiring artist, it is the culmination of the twelve years I've spent teaching watercolor painting classes.

In the popular movie *The Karate Kid,* Daniel wants to learn karate from Mr. Miyagi, his teacher and mentor. Mr. Miyagi has Daniel wax his cars with clockwise and counterclockwise hand rotations. Then he has Daniel paint his house using another movement. The next "chore" is sanding his deck. Daniel becomes upset by the labor and impatient to begin the karate lessons. When Mr. Miyagi finally begins to teach the first lesson, Daniel sees quickly that the exercises performed on the cars, house, and deck were all useful and important movements needed in karate. He sees that they gave him a solid foundation on which to build.

After this description, my students understand the importance of the simple exercises we follow when first learning watercolor. I have had students in my beginner classes who had previously painted for years. When they did all the beginner exercises, they were amazed to discover how much they did not know. They went on to improve significantly.

I am pleased to share all that has proven successful in my classes. This book is a complete guide for the future artist.

The book is designed just like my classroom sessions. You may notice that some descriptions are conversational in style. I wish I could be with you personally, to guide you, as if you too were in my classroom. This book is the next best thing to my being there with you. ▪

Supplies for Every Budget

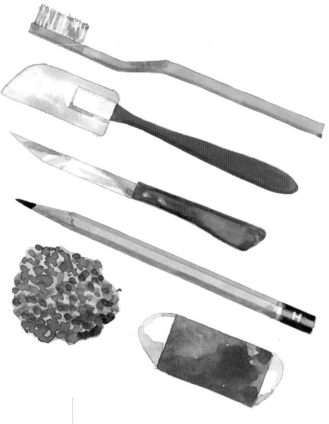

Helpful tools for creating texture—toothbrush, rubber or soft plastic spatula, metal knife, #H pencil, sea sponge, and PVC eraser

Items around the House

The good news is that you may already have some supplies around your house. For creating textures, you will need an old toothbrush, a plastic or metal knife, a razor or craft knife (such as an X-acto knife), two plastic containers (to clean your brushes), paper towels, kosher salt, sandpaper, a #H pencil and pencil sharpener, a white eraser and kneaded eraser, a rubber or soft plastic spatula, tracing paper, masking tape ($1/2$ inch to 1 inch or 1.25 to 2.5 cm wide), a small sea sponge, a sketch pad, disposable children's brushes (packages come with a dozen or more and are very inexpensive), rubber cement pickup (for removing rubber cement or liquid mask), and a scrap of Masonite board or plastic (about 16×20 inches or 40×50 cm). If you don't have all of these items, they can be purchased easily.

Rough-finish paper, 300 pound **Cold-press paper, 140 pound** **Hot-press paper, 90 pound**

**Results from using
different kinds of
watercolor paper**

Supplies to Buy

Everyone has a different budget when it comes to purchasing supplies. A quality art supply store or mail order company can help you with your selections. But keep in mind that using the finest-quality supplies will make a huge difference in your results. Therefore, I recommend that you buy the best professional supplies from the beginning.

You do not have to buy everything on my paint list (see pages 4–5). If you are on a limited budget, you may want to purchase only those items with a single asterisk next to them. The items with two asterisks are additional recommendations for a medium budget. Every item listed, with or without asterisks, is for the unlimited, or open, budget.

Student-grade supplies are available, but I find them to be a problem because the quality is not always the best and in some cases is actually very poor. Working with student-grade or poor-quality supplies will be frustrating. Also, if you decide you like painting and choose to continue, then you will need to learn the techniques all over again with the better materials. I like to think of it as the difference between whole milk and skim milk, or lemonade made from lemons as opposed to powdered lemonade; you get the idea.

Paper

You must buy 100 percent cotton (rag) paper. I use 140-pound cold press. There are heavier and lighter weights, but this paper is the most popular and what we use in class. Do not buy watercolor paper that comes on a spiral pad. This paper is usually not cotton and has manufactured products in it that will prevent you from painting properly. The best paper lasts longer and holds up to water and various techniques better. It also reacts to the paint better. The paper can be purchased in single 22 × 30-inch (56 × 76 cm) sheets or in money-saving packages in the same size. You can paint on either side of the paper and right over the watermark logo.

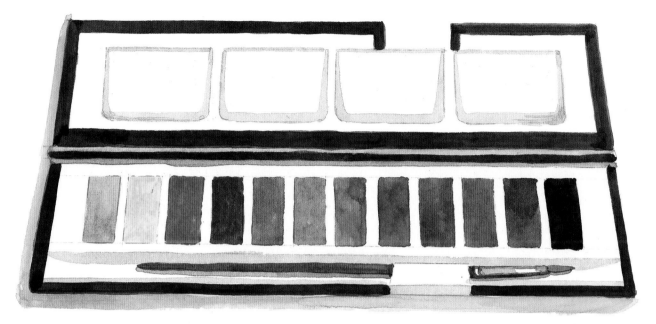

Pan paint

Tube paint

Paint

Most artists buy paint in tubes. I use both tube and pan paint. Pan paint is just like tube paint, but it is already dry and hard in the palette. Pan paint is ideal for painting on location and for travel. Some artists prefer to squeeze out fresh tube paint every time they sit down to paint. I will use fresh paint when I am painting on a full sheet of watercolor paper, but for most of my work (quarter sheets) I will use just what is on my palette. I usually have a generous amount of paint on my palette that has been squeezed out and has hardened.

You can buy pan paint with twelve colors, twenty-four colors, thirty-six colors, or forty-eight colors. I find that the twenty-four or thirty-six color sets have enough variety to suit my needs. I also like to have a tube of white gouache. It is wonderful for fixing things and making snow. More about that later. Sets of tube paints are also available. They are generally

student-grade. Sets may include black paint, which I never use in a painting. In time you will discover your own favorite colors. I sometimes use pink and turquoise as well as other accent colors.

Watercolor Paint Colors in Tubes

These are the colors that I use most.

Alizarin Crimson **
Antwerp Blue **
Burnt Sienna **
Burnt Umber
Cerulean Blue **
Hooker's Green
New Gamboge
Payne's Gray **
Permanent Mauve **
Permanent Rose
Prussian Blue *
Raw Umber
Permanent Sap Green **
Sepia **
Ultramarine (Blue)
Winsor Orange
Winsor Red *
Winsor Yellow *
Yellow Ochre **

* Recommended paints for the low budget.

** Additional colors for the medium budget.

Paints without asterisks are also recommended if you have an unlimited budget.

Brushes

Brushes are made by many manufacturers. It can be complicated to decide which ones to buy. There are sable brushes, synthetic brushes, and sable mixed with synthetic. I use combinations of all three.

The quality of the synthetic brushes has really improved. I use several all-synthetic brushes and they are just fine.

The important issue is how to pick a good brush. A quality art supply store will let you have some water to test the brushes. Swish the brush in the water, and then flick out the water onto the floor. A round brush should come to a perfect point with no "hairs" sticking out. The flat brushes should also stay together and not have any stray hairs. The next test is whether the brush is "dead" or "alive." Take the brush you just wet and press it against a clean sheet of paper. When you pull the brush away from the paper, it should spring back to its original shape. If it lays flat or is bent, it is not a good brush; it is dead. Generally, inexpensive brushes are dead and do not make nice points or edges.

Round brushes are often used for small areas. Specialty brushes, such as rigger brushes, are used for painting tall grasses and branches of trees and bushes. Another specialty brush I like is the fan brush (I prefer the stiffer oil paint fan brushes over the watercolor ones). The fan brush also makes great short grasses and other textures like wood grain. Flat brushes are used the most to make large washes, large areas, and skies.

If you are on a tight budget, flat brushes can be used instead of a fan brush. On a tight budget, you must have a 1-inch flat brush and a round #4 brush. You can do a lot of painting with these two brushes. They are also perfect for travel and painting on location.

Brushes to avoid

If you are on a medium budget, you can also buy a 1/2-inch flat brush, a rigger #4 or #6, and a fan brush. For an open budget, 1-inch, 1/2-inch, and 1/4-inch flat brushes are all recommended, as are #1, #2, #4, #6, #8, and #10 round brushes. Here's one last bit of information you should know about watercolor brushes— they are short. Oil and acrylic brushes are very long. The latter brushes are long because the paintings are usually done on easels. A few watercolor artists paint on easels, but I paint on a flat table. Some tables can tip up a little and that is OK too. But watercolor runs and moves, so a flat surface is better.

How you treat your brushes is also important. You are painting in watercolor. Water and oil do not mix. Therefore, do not use your fingers or hands to "play"

with the brushes. It is very tempting because it is like stroking a cat, but the oil or hand cream on your hands is not good for the brushes. From time to time, you can clean your brushes with a non-oily soap or dishwashing liquid. Never leave them in the container of water that you use for washing out the brushes while you are working; they will be ruined that way. If you take care of your brushes, they will last a long time. I still have some from years ago.

Note that 1 inch = 2.54 cm. The watercolor brushes shown on page 7 are close to actual size.

Palettes

I use a rectangular plastic palette with a tight-fitting lid. It has twenty wells in it to hold the paint and a large middle area for mixing paint. I have had this one for many years. There are a variety of palettes on the market. Some are round. All have wells for the paint. If you are on a tight budget, there are small palettes that are very affordable. You can start with them and in time invest in something larger. For a mixing area, you can use a white plastic plate.

Liquid Mask

Liquid mask is used for protecting the white areas of your paper so that you can paint large areas without worrying about painting around places that need to stay white. Use children's disposable brushes or a toothpick to apply it to the paper. We will go into more detail about this later.

Types of Watercolor Brush

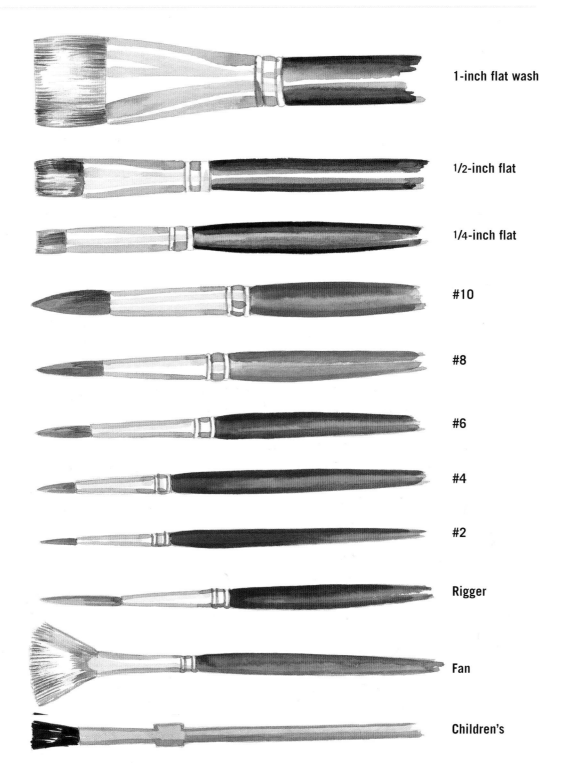

1-inch flat wash

1/2-inch flat

1/4-inch flat

#10

#8

#6

#4

#2

Rigger

Fan

Children's

2

Getting Started, Brush Stroke by Brush Stroke

irst of all, you need to be sure you are working in an area that has good lighting. And you need to be able to work without being distracted by people or pets, the telephone ringing, and so forth.

You also need to set up your worktable and supplies in an organized manner for optimal use. If you are right-handed, you can set up your table as shown in this illustration. Reverse this layout if you are left-handed.

There are two ways to paint on paper. One is on wet paper, and the other is on dry paper. Your subject will determine whether you will be painting on wet or dry paper. We will be doing two exercises on both types of paper.

Preparation

Take a full sheet of watercolor paper and firmly fold it in half. Be sure your hands are free of hand cream and oils. Tear the paper at the fold by hand. Take one of the half sheets you just tore and fold it in half. Then tear that by hand. You now have two quarter sheets of paper. Most of the exercises and paintings in this book will be painted on quarter sheets. Your quarter sheets should measure about 11 × 15 inches (28 × 38 cm).

Wet Paper

You need to soak your paper in a sink or container that is large enough to hold the paper flat. Do not use a sink that has been used for any oil such as salad oil or cooking oil. Remember, oil and water do not mix, and the combination will ruin your painting. You can soak the paper in

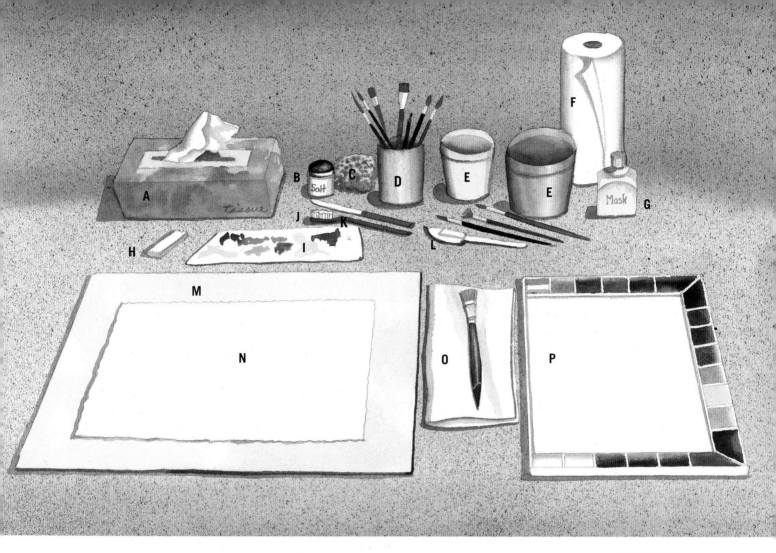

water at a tepid temperature for a few minutes. You cannot do this with inferior paper, however, because it will fall apart.

Remove the paper from the water and shake out the excess water. Place the paper onto your 16 × 20 inch (40 × 50 cm). Masonite or plastic board. Using a wet 1-inch flat brush, adhere the paper to the board by stroking the brush back and forth. If you have ever hung wallpaper, it is the same technique. You are getting the air bubbles out of the back of the paper. Some artists stretch their paper, but I have never found the need to do this with good paper. It will stay flat and not curl if handled properly.

You will need to work quickly while the paper is wet. If you have an answering machine for your phone, it should be turned on now.

Using your flat 1-inch brush, swish it in the container of water. Dab out excess water on the side of the container. Lather the brush in the paint. Then apply the paint directly onto the wet paper in large brush strokes. Wash out the paint from the brush and use another color in another area. Also, let the colors overlap a little. Don't think about what you are doing—just play with the colors and your brush. Do the same with all the colors on your palette. You will notice how the paint runs on the wet paper.

TABLE SETUP

A	tissue
B	kosher salt
C	sea sponge
D	container of brushes
E	containers for water
F	paper towels
G	liquid mask
H	white eraser
I	watercolor-paper scrap
J	toothbrush
K	knife
L	spatula
M	board
N	watercolor paper
O	folded paper towel
P	palette with paint

Playing with the colors on wet paper

Another example of playing with colors on wet paper

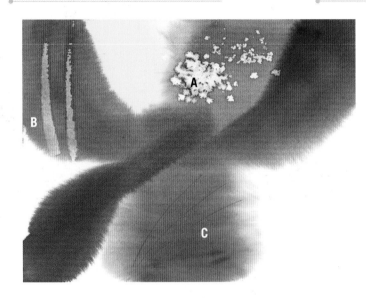

Experimenting with (A) salt, (B) moving paint with a spatula, and (C) scarring

While the paper is still wet, sprinkle a pinch of kosher salt on a small area of the paper. Do not go back into that area; let the salt work by itself.

Use your spatula and drag the paint in one area. You will notice that the paint is pushed away and the paper is lighter in that area.

Use the handle of your brush and drag the pointed end on the paper, scarring the paper. You will see that the paint is running into the scar and creating a dark line. This is another technique that is used in paintings.

Switch to a round brush, and start using the colors on the wet paper. Don't draw images—just play. If you have the rigger and fan brushes, use those too.

Use your sea sponge and see what texture is created. Just put a little paint from your palette onto a damp sea sponge, and press it onto the wet paper.

Take your toothbrush and knife, and put some paint onto the toothbrush. Stroke the toothbrush on the knife edge away from you and toward the paper.

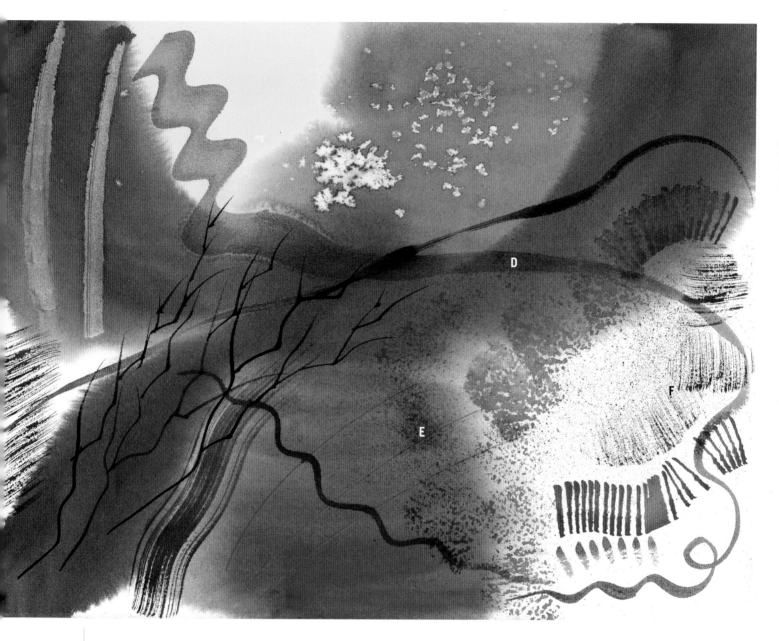

Experimenting further, with (D) a round brush line, (E) sponge texture, and (F) stipple

Sponge Textures

Different textures created by using the sponge on wet, dry, and damp paper

Wet paper

Dry paper

Damp paper

If you stroke toward yourself, the paint will splatter all over you, so be careful or wear a smock or apron. Look at the stipple texture that is created.

Depending on the temperature and humidity of the air, the paper should be getting drier. As the paper dries, the paint will spread less. Continue working on the paper as it dries. Once it is dry, play with all your brushes again. Use the sponge and toothbrush again. You'll notice that the textures change quite a bit when the paper is dry. It is time to see what has happened in the area of the kosher salt. It should look like snowflakes or stars. If it is a big blob, you may have used too much salt or the paper may have been too wet.

Study the sponge texture samples on this page and the toothbrush texture samples on the opposite page. You'll find rigger brushstroke samples far right on page 13 and other wet- and dry-paper brushstrokes on page 14.

Toothbrush Textures

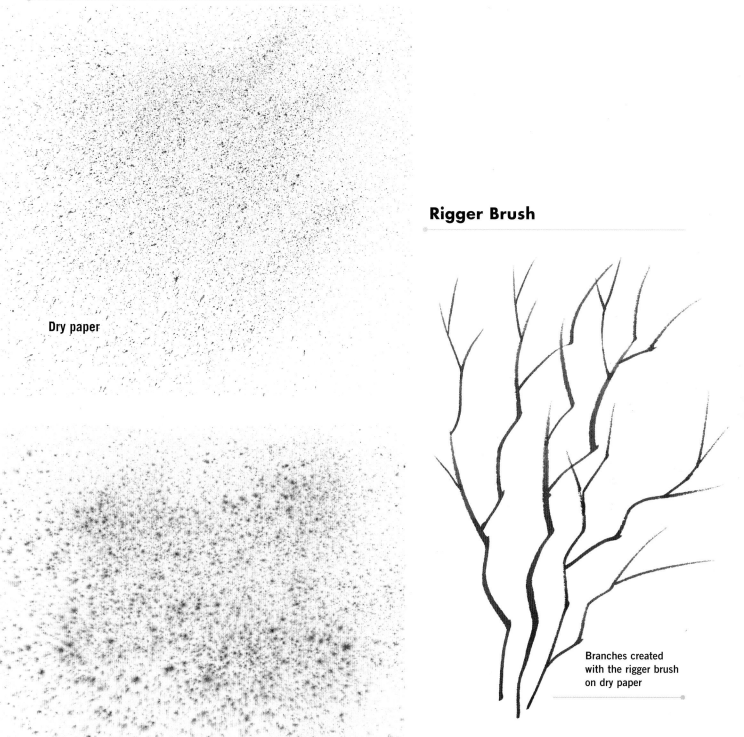

Dry paper

Wet paper

Rigger Brush

Branches created
with the rigger brush
on dry paper

Wet-Paper and Dry-Paper Brush Strokes

Strokes using the 1-inch flat brush on dry paper

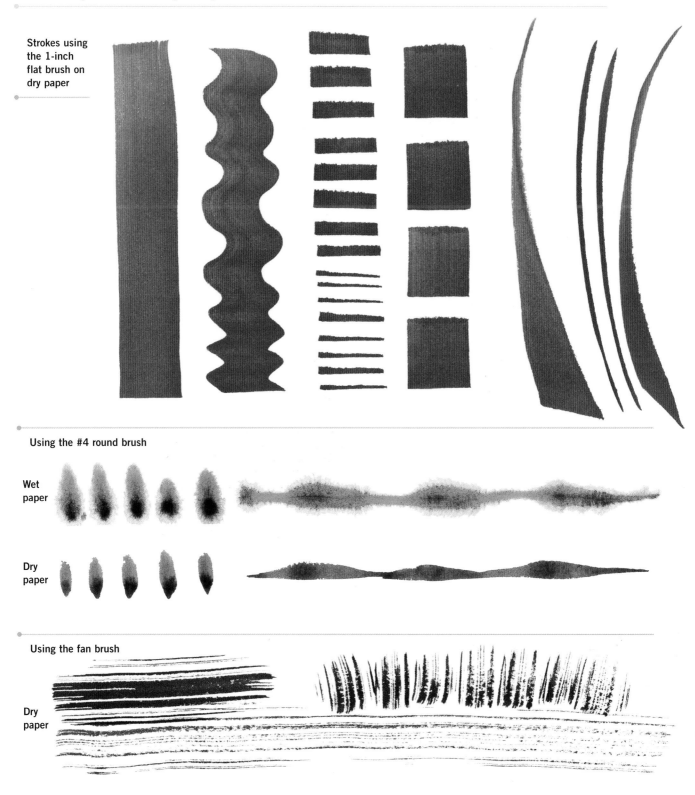

Using the #4 round brush

Wet paper

Dry paper

Using the fan brush

Dry paper

Texture Techniques

In your "play" project on wet paper, you used sponge, fan brush, and toothbrush techniques to create texture. With this next project, use small blocks on a sheet of paper to experiment with wet and dry textures. The purpose of this exercise is to get more experience creating these textures.

Creating Texture

FEW COLORS IN TEXTURES

Toothbrush

Fan brush

Sea sponge

MORE COLORS IN TEXTURES

Toothbrush

Fan brush

Sea sponge

Creating Three Values

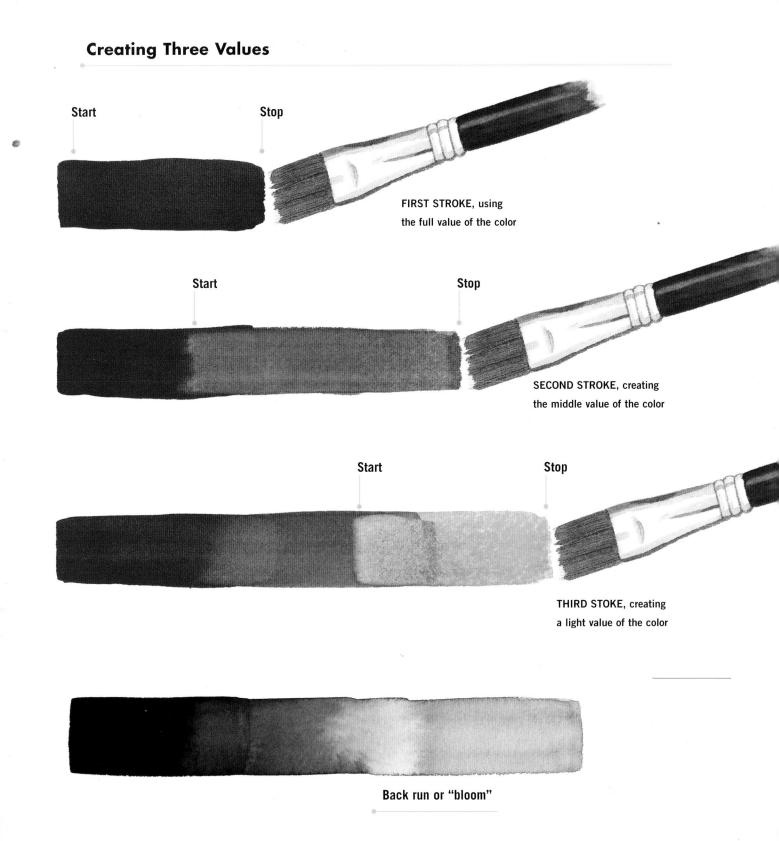

Start Stop

FIRST STROKE, using
the full value of the color

Start Stop

SECOND STROKE, creating
the middle value of the color

Start Stop

THIRD STOKE, creating
a light value of the color

Back run or "bloom"

Working on Dry Paper

Working on dry paper, make a color chart of all the colors you have. You will learn how to make three values of each color. When speaking of color *value*, we mean its gradation from dark to light and everything in between. But we will be concerned with only three values at this point. More values will be introduced in another exercise.

Use a quarter sheet of dry paper. You can place it on your board. There's no need to tape it down. Use a pencil to write the names of the colors on the chart. In time you will become more familiar with the colors and their names.

Take your flat brush. Lather up one of the colors on your palette with water and the brush. Do not use too much water. You do not need to make a large puddle for this little exercise. Make a broad stroke on the paper. About two or three inches (5 to 7.5 cm) will do. That is the full value of the color, or *hue*.

Wash out the brush and get rid of the excess water by dabbing it onto the paper towel. Go back into the first stroke, about halfway, and pull out some color with just the plain water on your brush. That will create the middle value of the color.

Wash out the brush again, dab out the excess water, and go back into the second value of the color, and draw that out too.

Repeat the same process with all the colors. (See the top three brush strokes on page 16.)

You may notice something occurring commonly called a *back run, blossom,* or *bloom,* shown on the bottom of page 16. It happens when you go into a painted area with a brush that has too much water on it. Remember to dab the brush onto the paper towel.

Color Chart with Values from Dark to Light

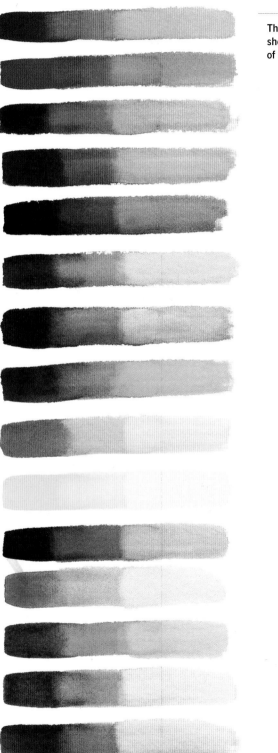

This color chart shows three values of each color.

Color Wheel

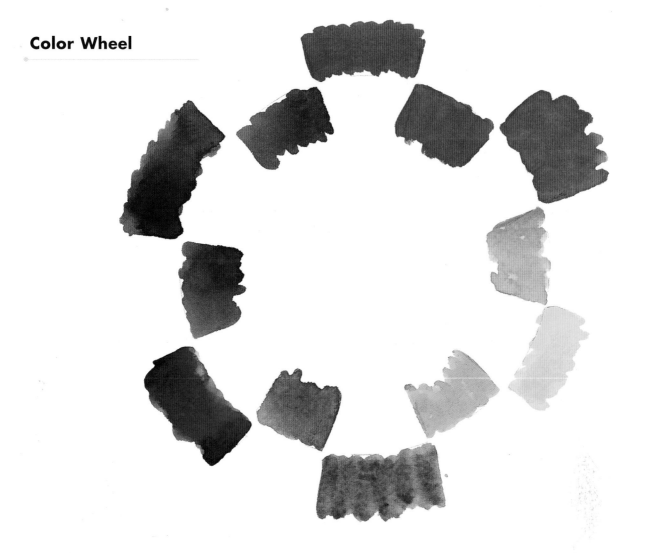

Making a Color Wheel

Whether you have just the three *primary colors* of red, yellow, and blue, or an assortment of colors, you will need to know how to mix colors to make additional hues. Do this on an eighth sheet of dry paper; cut your quarter sheet in half to make an eighth sheet. You can make a very loose color wheel, or if you wish you can use a ruler and circle template and make a perfectly arranged one. Mine is painted loosely. Lay out your colors as in the illustration.

If you are using only the primary colors, you can make the secondary and tertiary colors by mixing the primary colors. To make orange, mix red and yellow together on the open surface of your palette. To make green, mix yellow and blue. To make violet, mix blue and red. Orange, green, and violet are the *secondary colors*. The *tertiary colors* are yellow-orange, blue-green, red-violet, and so forth.

The more you learn about painting, the more you are going to hear these terms used. Color and *color temperature* can set the mood of a painting. Other terms you

will hear are *complementary colors* and *analogous colors*.

Complementary colors are directly opposite each other on the color wheel. Red and green are opposite, as are blue and orange. The complement of a color can be used to dull a color that is too intense.

Analogous colors are colors next to each other on the color wheel. If you have red, then the analogous colors would be red-violet and red-orange. Another example would be blue with the analogous colors of blue-violet and blue-green.

One more factor is *color temperature*. Half the color wheel is warm and the other half is cool. The warm colors are on the red side of the wheel. The cool colors are on the blue side. Yellow is warm. Green is cool.

Mixing Colors

Using a quarter sheet of dry paper, we are going to work more with colors. This time, unlike the first exercise that involved play, we'll put more thought into what we're doing. Take different colors on your palette and mix them with others. See what you get. Do this as many times as you like. Mix two colors together and see

Mixing Colors and Creating Values

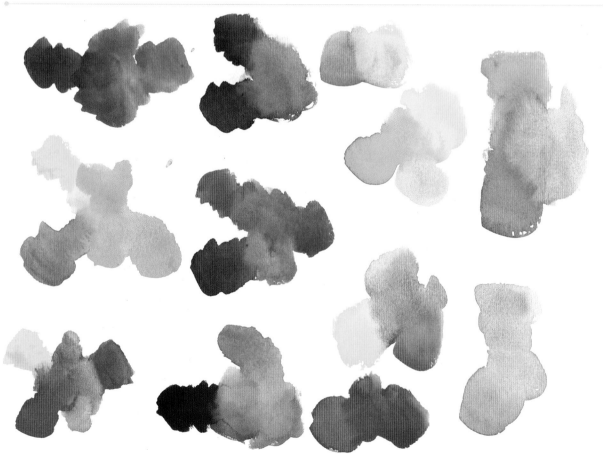

Creating Colors by Glazing

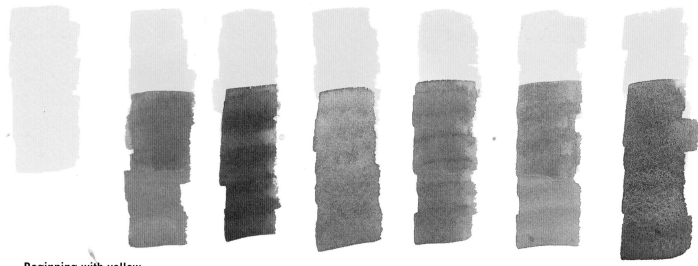

Beginning with yellow

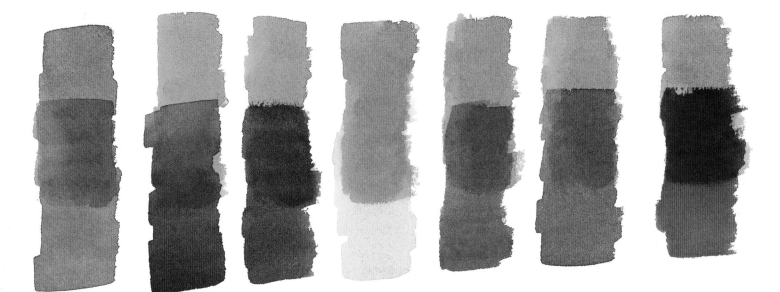

Beginning with green

what you get. Mix three colors together and see what you get. Also, add some water to the colors and see how they look when they are watered down to midrange values and light values.

Glazing

Glazing is often used in watercolor painting. It is a good idea to experiment with this technique so that you will have it at your disposal when you begin painting.

On dry paper, lay down a color in a rectangular shape. You can make a row of the same color. Make another row with another color. Leave some space between them. When these are completely dry, take other colors and lay them over the color you painted earlier. Have some of the new color go onto the white of the paper so that you will know what it looks like by itself. When everything is dry, you will be able to see the colors that have been created from glazing. See colors created by glazing on these pages (20 –21).

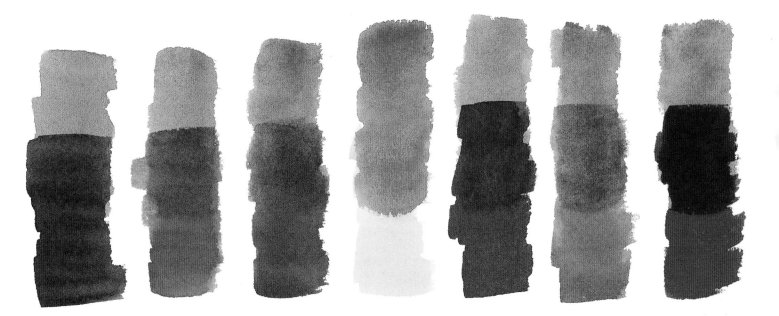

Beginning with blue

Color Relationships

Color relationships are also important. One color next to another will make each hue appear slightly different. So experiment with some boxes of colors. Do this on dry paper. Lay out small boxes of different hues. When the paint is dry, paint a border around the color.

See how yellow looks surrounded by blue, as opposed to yellow surrounded by red. Red will make the yellow feel warmer, while blue will make it cooler and perhaps greenish-looking. When you are painting, notice how one color seems to change depending on the colors that are around it.

Showing Color Relationships

Yellow center

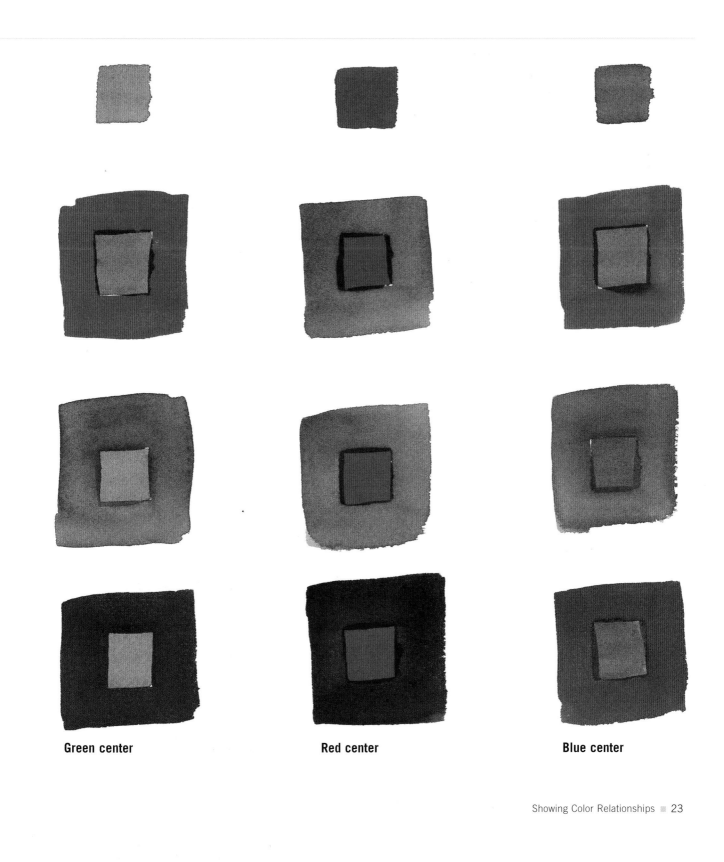

Green center **Red center** **Blue center**

3

Laying Down a Solid Foundation

Removing Shapes

One of the fears that many people have about painting with watercolor is that you cannot fix anything. That is totally untrue. This exercise will show you how to remove paint. It is true that some paint will stain the paper and that you cannot remove it 100 percent; however, most paint colors can be removed from 10 percent to 90 percent.

Paint square

This exercise will be done on dry paper. Use an eighth sheet of paper (your quarter sheet cut in half again). In the corner, paint a square box about 4 inches (10 cm) wide using Burnt Sienna. If you do not have Burnt Sienna, then use a brown. If you bought just the primary colors, use red. Paint it on the paper with your 1-inch flat brush. Let it dry.

Making a Circle

Take your round brush and put a little clean water anywhere on the box. Rub the water using a small circular motion, creating a circle about half an inch in diameter. As the paint starts to loosen, dab a tissue on the wet spot to lift up some of the paint. Wash out the brush and repeat these steps until you have removed enough paint to make a difference. (See page 26, top.)

Creating a Line

Put two pieces of masking tape parallel to each other with a little space in between. Take your sponge and dip it in clean water. Wring out most of the water so that the sponge is just damp. Rub the sponge in between the pieces of masking tape, and dab a clean tissue on the wet spot. Remove the tape and you have a nice line.

If, for instance, you want to have a light post in a painting, after you finish the scene, you can add the light post by using this masking-tape method. (See illustration above right.)

Creating a line using masking tape

Removing Paint

Circle removed

Shape removed

Line removed

Creating a Shape

Save the plastic lids that come with boxed notecards. These are perfect for making a stencil. Use an X-acto knife and cut out a shape in the middle of the plastic. You can cut a small bird in flight, the sail of a sailboat, or whatever you like. Remove the shape you just cut out so that you have a shaped hole in the plastic. Place the plastic over the painted box. Using the damp sponge method, rub the stencil area and remove the paint. Blot the area with a tissue. Remove the stencil and you have your shape on the paper. If you were painting a sky and decided after the paint dried that you wanted a white seagull or some other lighter object, you could fix your painting. (See examples on page 26.)

Paint can also be removed from wet paper, as shown below. You remove the color by using a clean brush that is just slightly damp (A). You can also blot with a tissue (B) or a cotton swab (C).

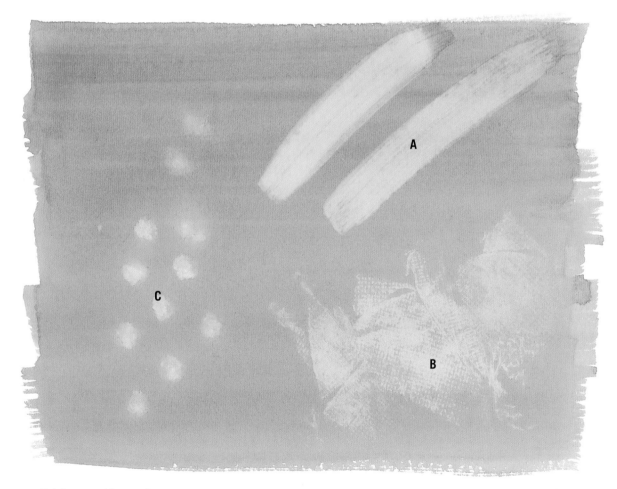

Paint removed from wet paper

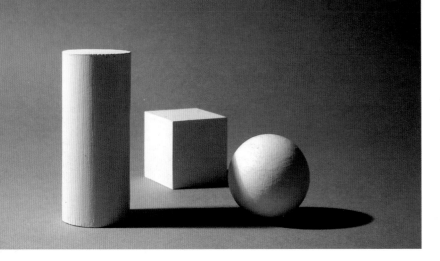

Light from the left

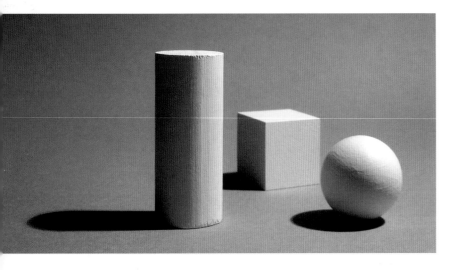

Light from the right

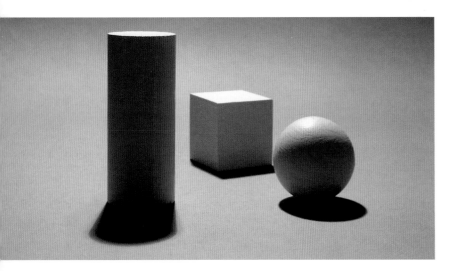

Light from the back

Look at each photo to see how the light and shadows fall on the objects (ball, cube, and cylinder) depending on the location of the light source.
Photos by Michele Arcila

Creating Shapes and Shadows

Learning how to form shapes and shadows is very important. Almost all shapes are either round, square or flat, or cylindrical. Practicing painting these shapes will help you with future painting.

If you paint a lighthouse, how would you make it appear rounded? How would you paint the shadow that is cast from a teacup? Almost everything you paint will cast a shadow and have shadows itself, especially during daylight hours, that help define its shape or volume. There would be fewer shadows on gray and foggy days.

Painting shapes is similar to painting your color chart, in that you blend the color into other values. Observe these five photos of the cylinder, cube, and ball to see how shadows are cast by light sources from different directions and how the objects themselves appear.

Now take a sheet of paper, and, working on dry paper, draw in the shapes and paint the shapes and shadows. Blend the paint as you did in your color chart exercise, but use more values and blend it a little more smoothly.

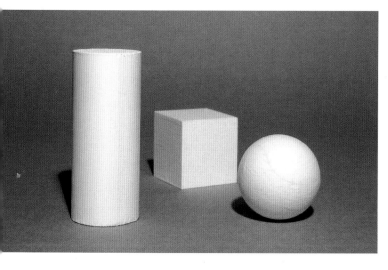

Light from the front

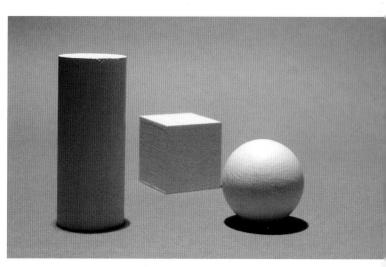

Light from above

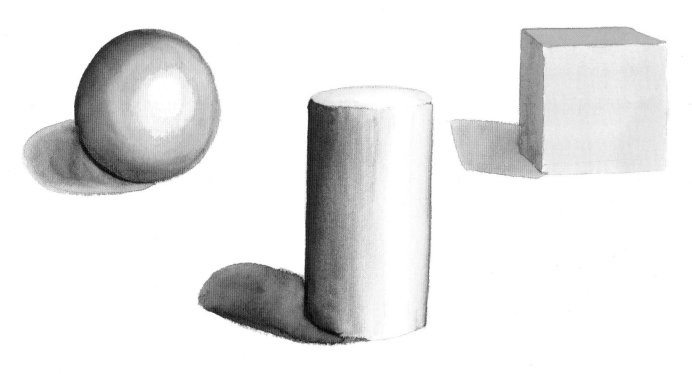

Painting shapes and shadows

Positive and Negative Space

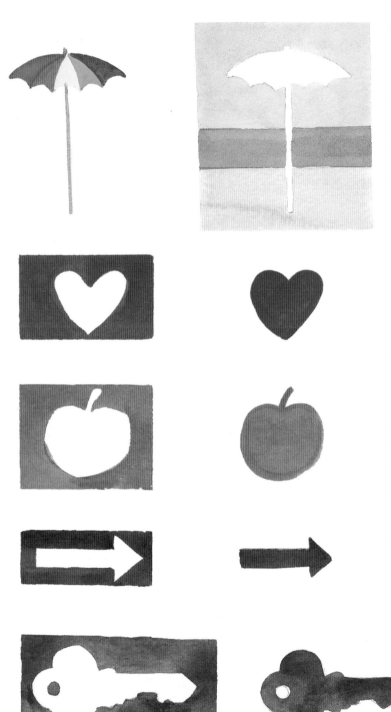

Awareness of positive and negative space is another important aspect of building your foundation as an artist. You may not see it right away, but in the future when you are painting a subject, you will recognize the value of this lesson.

The positive space is the subject itself. The negative space is the space around the object that creates that object. If you did not have the negative space, you would not see the shape.

Almost every painting has positive and negative spaces. This helps to make the painting exciting. The positive and negative shapes play off each other.

Paint whatever simple subject you want in both positive and negative space. It is very easy to paint in the positive; you have to train your eye and brain to see and think in the negative. Paint a heart, key, arrow, letter, flower, leaf, and any other shapes in both positive and negative. You can draw your subjects in first with pencil if you have trouble imagining the shape. When you get the idea, try something more challenging like the beach umbrella or some other, more complex shape.

In my classroom, I ask students to paint a white teacup on a white table against a white wall using many colors. They stare at the white paper for a long time. You can look at a blank piece of paper too. Try to visualize how this could possibly be accomplished. This exercise will stretch your imagination. It will help you to notice things around you more—things you take for granted or maybe never thought about. For instance, if the sun shines through a colored glass vase, it will cast the color in its shadow. The same thing will happen with colored balloons. Light can also make color "bounce" from a solid object to another object or surface.

Many of my students have a hard time trying to figure out this assignment, but my more imaginative students get this puzzle. It helps the students understand shapes and shadows. It makes them realize that shadows are not always created with gray paint.

Most students who do not comprehend the use of shapes and shadows or negative space will draw something like the outline of a teacup shown above right.

But someone who understands the exercise will paint the teacup in many colors, like the one shown below it.

Outline of a teacup

The teacup in color and with shadows and negative space

4

Painless Perspective

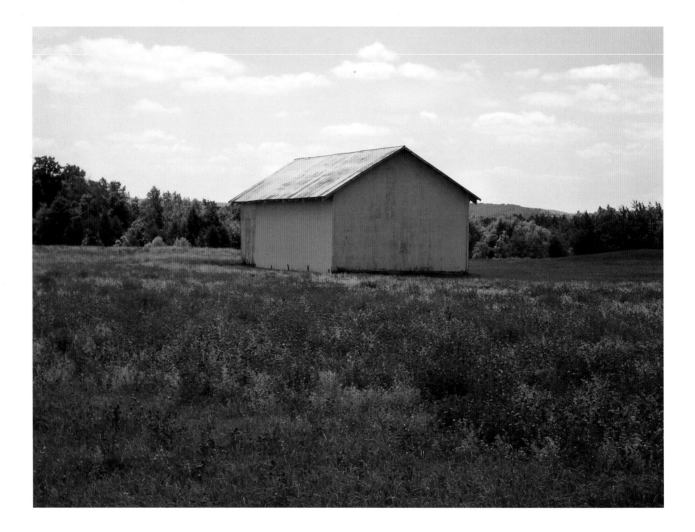

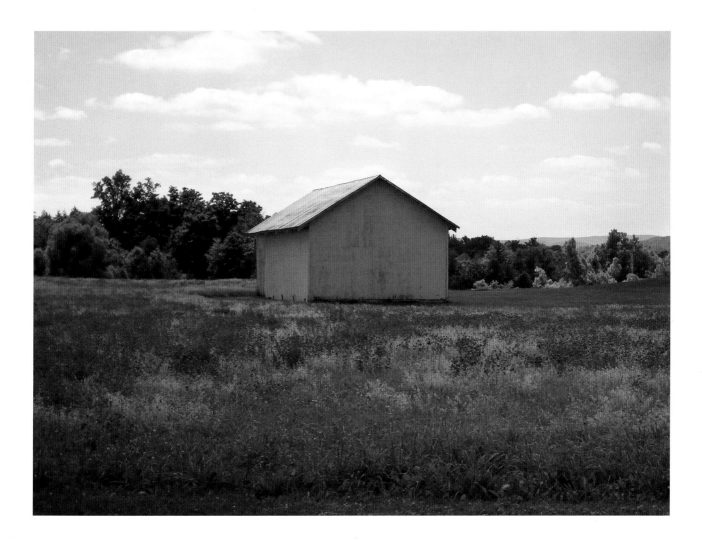

This is the easiest subject I teach and also the shortest chapter in this book. There are many books on the subject of perspective that take a more complicated approach, although I have never found any of them to be all that easy to understand. I once called my friend Audrey and asked her how she does perspective, and she said, "If it looks right, then it probably is." My method of teaching perspective is simple: Cheat! That's right. All this jargon about vanishing points and horizons and so forth is just too complex.

Transfer Method

I use technology to make my life simple when creating a scenic painting. I just take the photo I am working with and blow it up on a photocopy machine to the size I want. I use a light box to trace the image, but you can also use the glass of a window or door on a sunny day. I use black pen on the tracing paper and then transfer the line onto the watercolor paper with a #H pencil, again using a light box or window or door. I recommend this transfer method—it's fast and easy.

Photos showing different views that can be used to practice drawing perspective

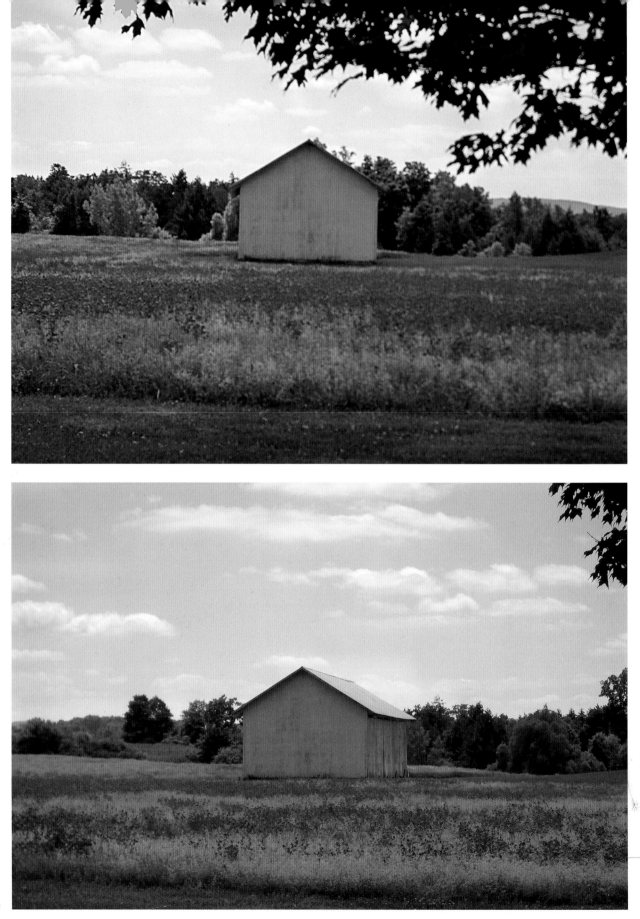

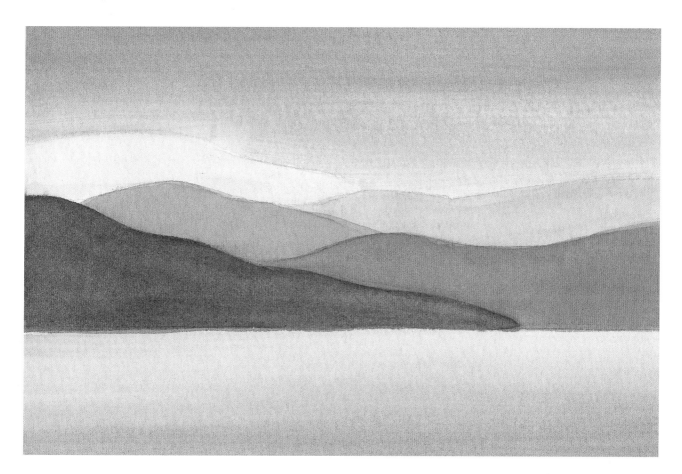

Perspective

Consider the photos of a windowless building in my town on pages 32–34. I took photos from various angles to show what it looks like from different sides. Notice the angles and the landscape around the building. Use them to practice drawing perspective; just enlarge and trace. You can also trace and enlarge the tracing, but your pen line will enlarge too.

One other note about perspective: This sketch showing layers of a mountain range illustrates how objects or mountains in a landscape get lighter in value the farther away they are. This is generally the rule for landscapes on clear or sunny days. Usually with lakes or oceans, the water gets darker the farther away you go. Skies are usually darker above you but get lighter toward the horizon.

Mountain range with increasingly lighter values in the distance

More views that can be used to practice drawing perspective

5

Simple Lessons
in Values

Multiple Value Study

Earlier you learned how to make three values of one color while creating your color chart. Now you need to learn how to mix your paint with water to create even more values. To do this, you will work on dry paper. You can use a round brush or a flat brush.

Start with the full strength of your darkest color; it should be Payne's Gray. (Use blue if you bought just three colors.) Paint this on your paper in a small square or circle. Put some of the paint onto the mixing area of your palette. Add a little water to the paint, and paint that onto the paper next to the last value. Keep mixing

water into your paint until you have a very light, almost undetectable value of the color. The full range of values will be very important to you in the future.

Monochromatic Painting

Before venturing out into the world of watercolor painting in full color, it would be better to do another exercise. You need to walk before you can run. A monochromatic painting is one color—*mono*, meaning one; *chroma*, meaning color. You can use Payne's Gray again for this. (Use blue if you bought just three colors.) You will be painting a simple farm scene on wet paper to start.

Multiple values, created by adding more and more water to a single color

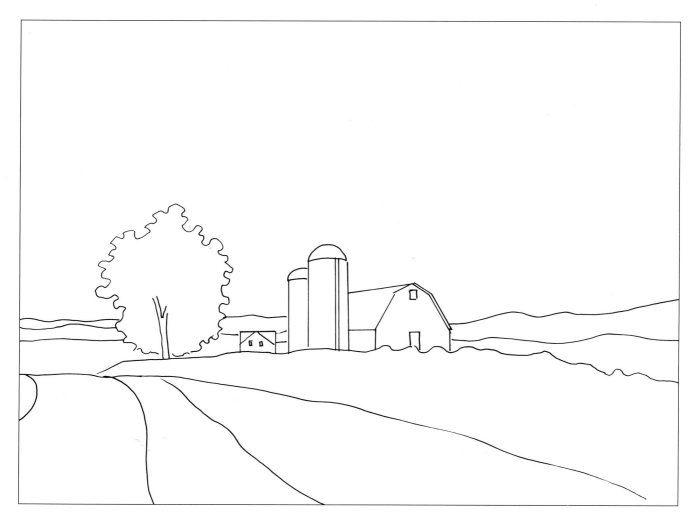

Tracing

Draw the scene onto your paper by using the transfer method (see page 33). You can use your liquid mask for the first time here to cover the silo and barn because they are both white. Use a children's throwaway brush for this; liquid mask will ruin a good brush. The liquid mask shouldn't be applied too thickly. Let it completely dry. Again, drying time will depend on your environment. An hour or so should do it; just make sure it is not still wet.

The liquid mask appears yellow in the roughs on pages 38 and 39. Other masks may be orange, gray, or clear. All preserve the white of the paper until they're removed.

Wet your paper as you did in your play exercise. Place it on your board, and get the air bubbles out of it with your large flat brush. Using your large 1-inch brush, paint in a solid sky by stroking from side to side, getting lighter toward the horizon. Put some of that sky value in your

Step One

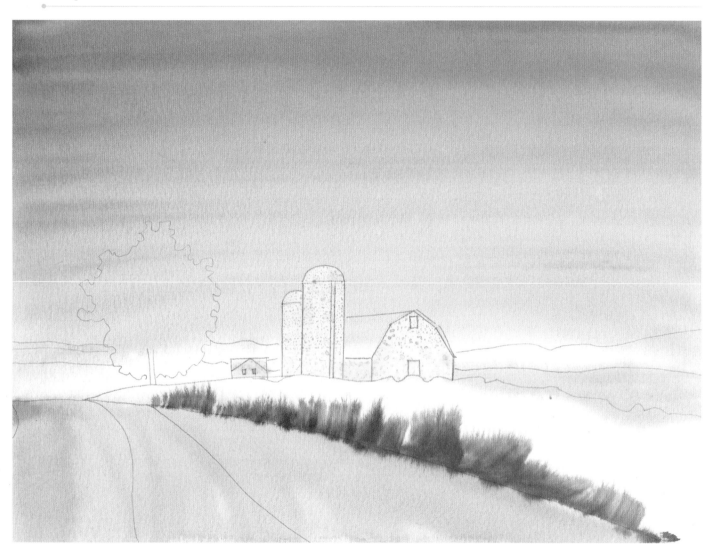

foreground. At this point, your paper is not as wet as when you started, especially if you are in a dry environment.

Paint your background and horizon next. You can put shadows in now, too. As the paper dries even more, you can add

Step Two

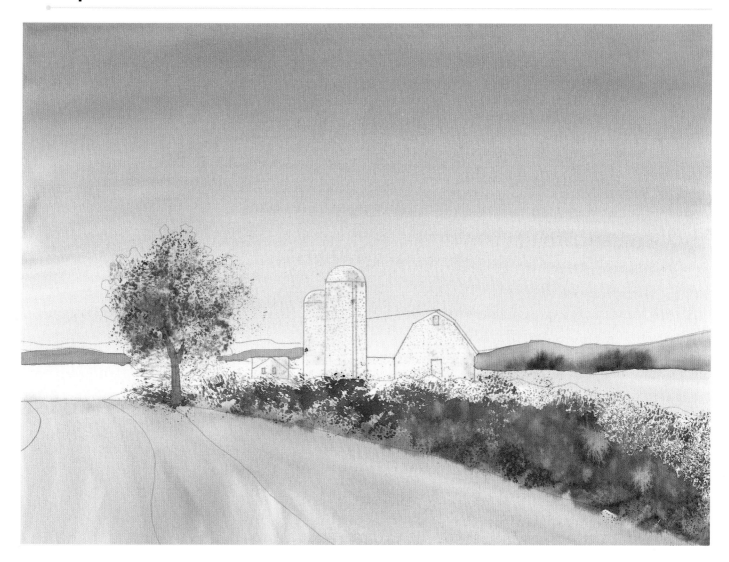

further detail, like the spongework in the tree and bushes along the road.

Now add the road. You can also splatter the texture with a toothbrush in the foreground. Cover the sky and the other areas with newspaper so that the splatter does not go all over.

Final Step

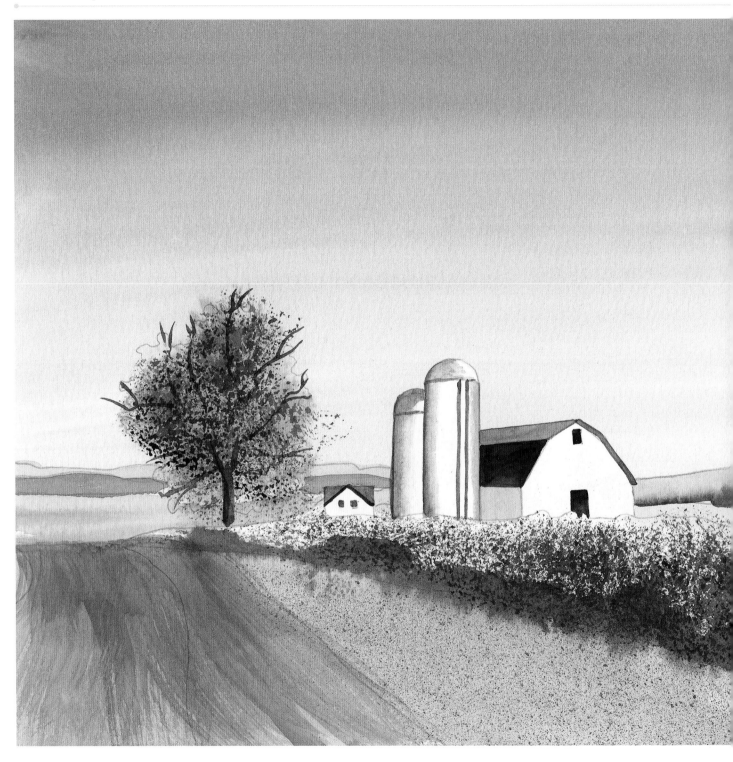

Let the painting dry. Once it is completely dry, you can remove the liquid mask with your finger or a device called a "rubber-cement pickup." Now you can add the shadows to your silos and building along with the barn roof and the open door and vent. Add the details to the house in the background too.

When all the paint is dry, pick out all the values in your painting that you have on your value chart. Did you get them all? If not, try to add more.

6

Painting Skies

Simple Sky and Beach

love painting skies. In the beginning, this may be a challenge for you, but take heart—it gets easier in time and with practice. One good thing about this painting is that the sky part is done in one minute. (Yes, just 60 seconds!) In order for the perfect sky to be created using my method, it needs to be made that quickly.

This is your first real painting; this is not an exercise. We are going to keep it simple and limit the colors so that it doesn't become confusing. The important thing to remember is that if you don't like the way your sky is turning out, you can run to the sink, wash it out, and try again. You can do this a few times. If you do not use 100 percent cotton watercolor paper, however, you will not be able to do this.

Tracing

Step One

This is a good time to turn on the answering machine on your phone if you have one. Any interruptions will be a disaster, because you must work so quickly. Time yourself, if you can.

Take a quarter sheet of watercolor paper. Using a #H pencil, lightly draw a simple horizon line about one-third of the way up from the bottom of the paper.

To one side of the paper, draw a little dune and some grasses. This will guide you where you want to paint later.

Soak your paper in a clean container for a few minutes. (See page 8.) Remove the paper and gently shake out the excess water. Place it on your board and remove the air bubbles with your 1-inch flat brush. Set your timer for 60 seconds or

Step Two

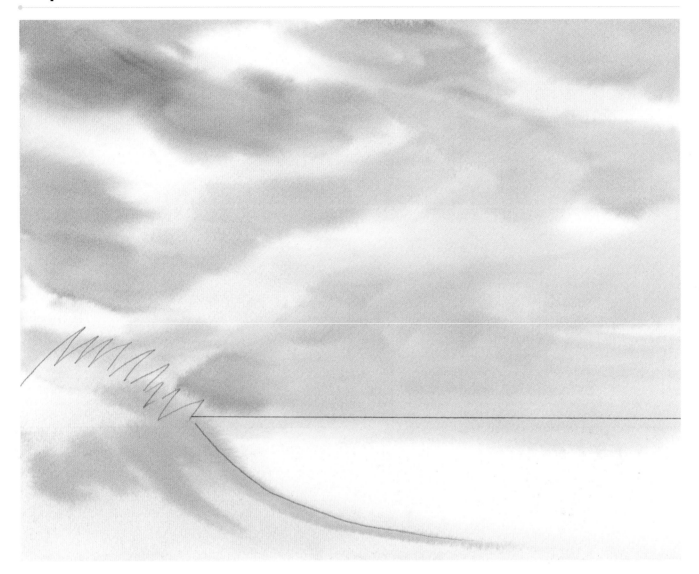

check your watch. Working very quickly with your 1-inch flat brush, brush on a pale wash of Yellow Ochre sporadically, just to warm up the paper a little bit. Use the wide part of your brush. The white of the paper looks a little cold, so a little warmth is good. Add some of the Yellow Ochre wash to the foreground too; this will keep a color and temperature balance in your painting. Use yellow if you do not have Yellow Ochre.

At this point, you should have about 50 seconds left. Yes, remember, I did say work fast. Use your flat 1-inch brush again, but now with Antwerp Blue (or whatever darker blue you have), starting at a top corner (wherever you are most comfortable, depending on whether you

Step Three

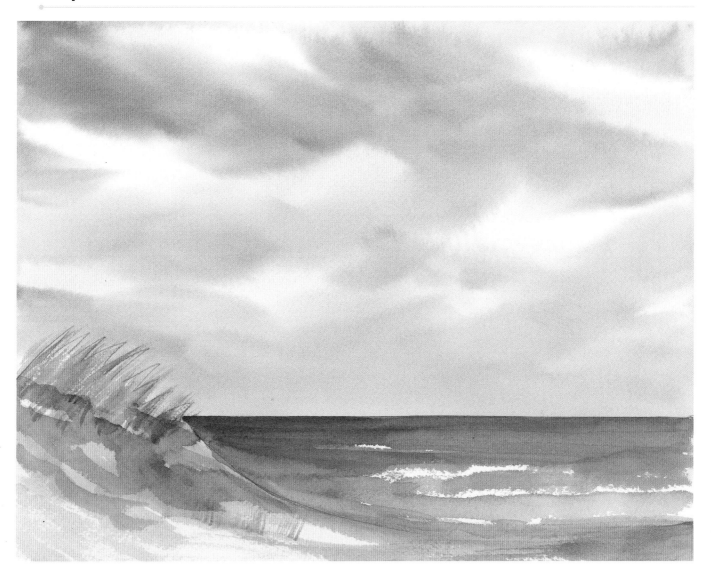

are right- or left-handed). Use quick strokes to paint the sky, leaving the white of the clouds. Now you will understand the importance of your exercise with positive and negative space. The clouds are created by painting the blue negative space of the sky. Add a little of the blue to the foreground, again to keep a balance of color and temperature from the top to

the bottom of the painting. You will not go back into the sky area again.

Check your time. You should have finished at 60 seconds. If you did not, then stop and wash out your sky in the sink and try again. Never blot the paper with a tissue or towel. If your sky is good, you can continue with the next step. If you are not happy with your sky, wash it

Final Step

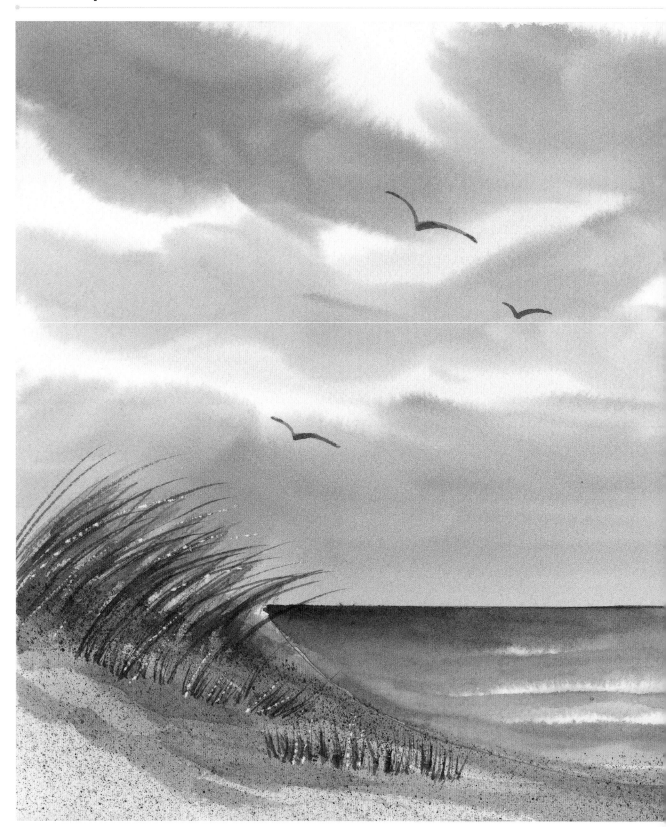

out in the sink and start again. You do not have to soak your paper again.

Add a little color to the foreground. Use a light Yellow Ochre and a little Raw Umber in the dune and sand areas. Let that area dry a little; do not overwork it. If the paint is no longer running on the paper, you can begin to add the ocean. Use Antwerp Blue and a little Sepia in some of the shadow areas of the dune and beach. Let this dry for a little while.

When the paper is not quite dry, you can add a little of the softer grassy areas. Use your fan brush and some Yellow Ochre with Raw Umber. For a little variety, use Antwerp Blue and Sepia.

Note: If you bought just the three colors, then mix them on your pallet to make other colors—for example, red and green make brown, and yellow and blue make green.

Now I like to finish off my painting by perhaps adding more contrast in the ocean. Keep it simple—just work with different values of Antwerp Blue. This is where your value study earlier will pay off. You can still use your flat 1-inch brush for this area, but just turn it sideways to the narrow part.

Once the paper is dry, you can add the same colors with the fan brush and some taller individual grasses with the rigger brush. Also, cover the sky and ocean with newspaper and splatter some texture onto the sand with your knife and toothbrush. I like to use Raw Umber and Sepia.

If you want to show a little life in the painting, add a few seagulls in the distance with your rigger or #2 round brush. As you can see, most of this painting was completed with the 1-inch flat brush, just held differently for the various tasks at hand.

Skies—What Not to Do

Here are some examples of what not to do when painting skies.

First of all, do not paint on dry paper. You will not have soft clouds. See the rough sketch of sky below and note the hard edges of the clouds.

Do not blot the wet paper with a tissue or towel. You will have hard edges and texture. See the rough sketch of a blotted sky shown opposite.

Sky painted on dry paper. Note the hard edges.

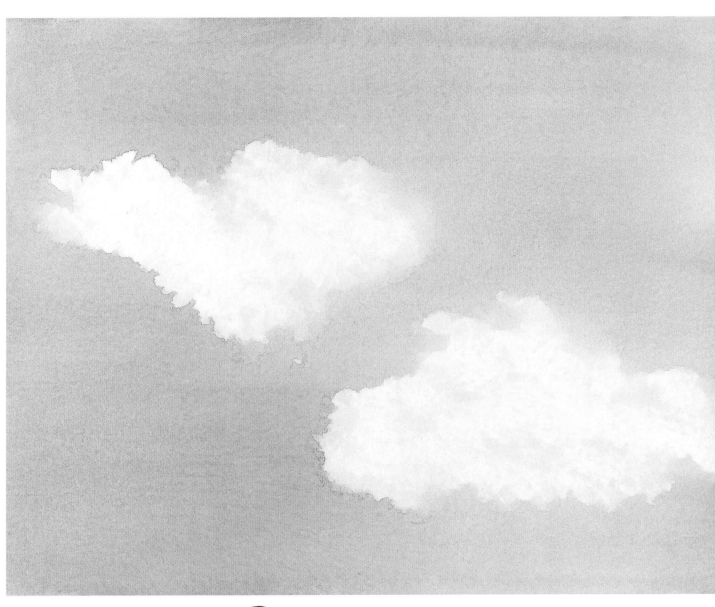

 Sky resulting from blotting wet paper.
Note the hard edges.

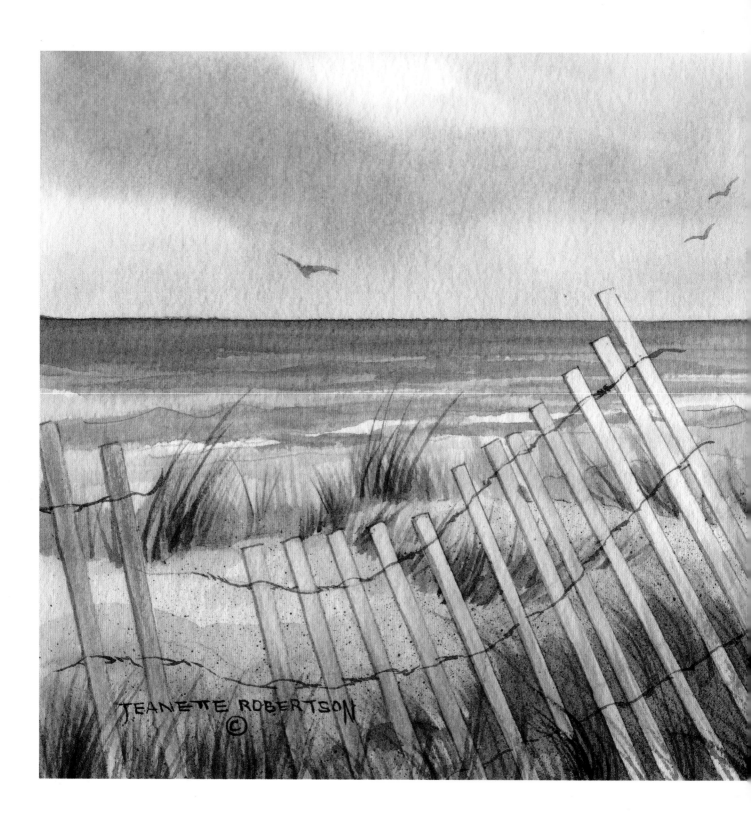

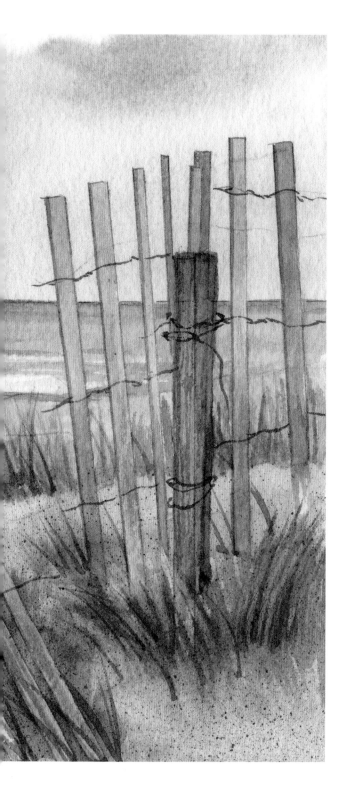

More Advanced Sky and Beach

When you have mastered the basics of how to paint a sky and a simple landscape or seascape, try a more challenging scene. In this beach painting, I added other elements. The windblown storm fence adds a nice foreground to the beach scene. The texture of the wood is warm and rustic. I also added some greens to the grasses. The ocean has another (analogous) blue added to it.

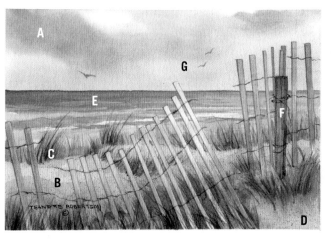

More advanced beach scene, showing (A) Step one—60-second sky, (B) Step two—foreground, (C) Step three—grass, (D) Step four—stipple, (E) Step five—ocean, (F) Step six—fence, and (G) Step seven—seagulls

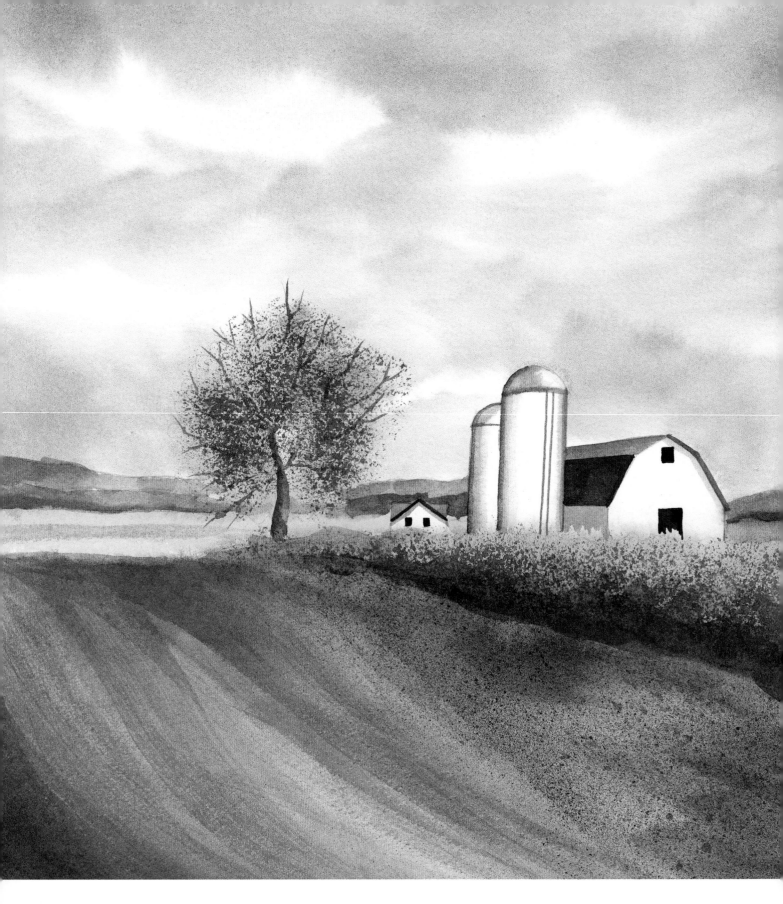

Sky with Barn

In the monochromatic painting (pages 36-41), you learned about the different values. Now you can take the same subject and paint it in color. If you wish, you can try another landscape with a building. Follow the same order you used in the monochromatic painting, but this time paint a 60-second cloudy sky. Add color where needed. You can use your 1-inch flat brush for most of the painting. The last details, when the paper is dry, can be added with a round brush, and textures can be made with a sponge and toothbrush stipple.

Use liquid mask to protect the white of the barn, silo, and house.

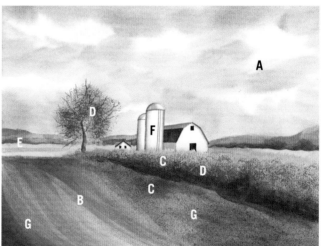

Farm scene, showing (A) Step one—60-second sky, (B) Step two—adding blue to foreground, (C) Step three—undercoat for bushes and ground, (D) Step four—texture in tree and bushes, (E) Step five—background, and (F) Step six—house, silos, and barn

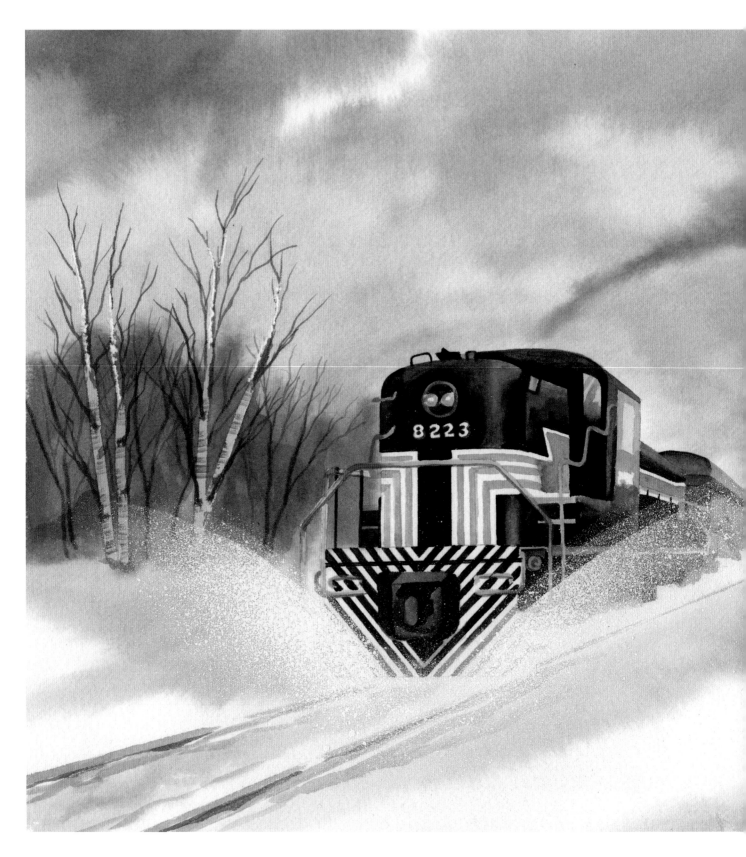

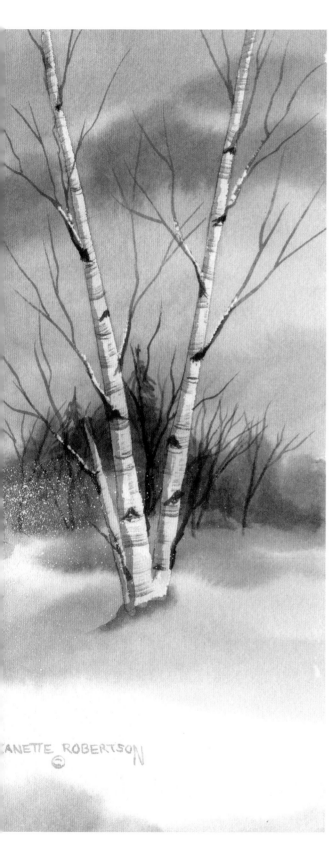

ANETTE ROBERTSON

Train in Snow

One of my favorite subjects to paint is trains. Paintings of trains are among my best sellers. Some female artists concentrate on "feminine" subjects, such as flowers. However, when looking for a watercolor painting to buy for a man, it is almost impossible to find something men will like. I also paint fish, trucks, wildlife, and other "masculine" subjects. I find that everyone enjoys boats and landscapes.

This train scene (shown at left and below) is set in the Adirondacks of New York. I love the contrast between the dark value of the engine and the white of the snow. You also really get the feeling of the train plowing through the snow with the snow flying off to each side. I used permanent white gouache in a tube for the flying snow in this painting. Gouache

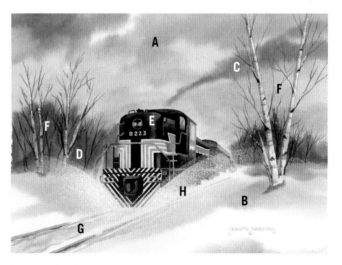

Scene with train in snow, showing (A) Step one—60-second sky, (B) Step two—foreground shadow, (C) Step three—smoke, (D) Step four— background trees, (E) Step five— train, (F) Step six—birch trees, (G) Step seven—train tracks, and (H) Step eight—flying snow.

Stencil

is a water-based paint that is more opaque than transparent watercolors. This paint is wonderful for fixing small problems and for making snowflake splatter. To paint the effect of flying snow, I use a stencil (see the directions below) and the stipple technique (shown on pages 10–15). Note: The train is painted with Payne's Gray and Sepia, not black paint.

Making a Stencil

To make a stencil, use a manila folder or some other cardstock. Draw the shape you want to use for your stipple technique. Cut the shape out with scissors.

Remember to protect the areas where you do not want to have the stipple show; newspaper is good for this. Depending on the painting, you may need more than one stencil. When the painting is

Rough sketch
Before birch trees

completely done and dry, you can place your stencil on it and apply the stipple.

Spatula Use

In the train painting, I had planned ahead and used liquid mask on my birch trees. If you find yourself in a situation where you did not prepare, but find that once you have started a painting you need to add something, you can use a rubber or soft plastic spatula to push away the paint, as in the play exercise. These rough sketches, left and below) show the "before" and "after" scenes of a forest, with the added birch trees in the second sketch created by using a spatula. This technique will work only with wet paint.

Rough sketch
After birch trees

Rough color sketch of salt field of flowers

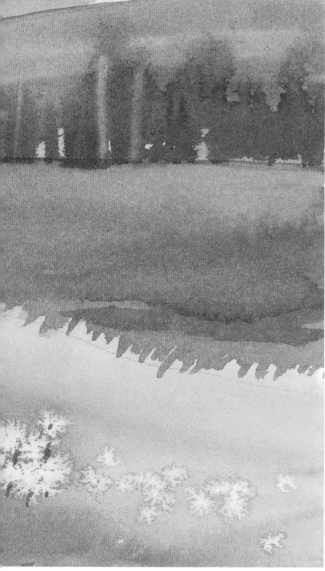

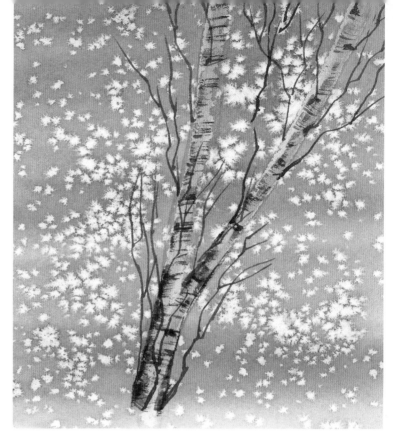

Snowflakes

Along with using a rubber spatula to
make the birch tree, in this painting
(above) I used kosher salt to create the
snowflakes. I painted the blue background
and then moved the paint with the
spatula to create the birch tree. I then
sprinkled the salt on the paint while the
surface was still wet. Once the paint was
dry, I removed the salt and painted the
details of the tree with a rigger brush.

Field of Flowers

The field of flowers (painting at left)
was created by sprinkling on kosher salt
while the paint was still wet. When the
paper was dry, I added the details to
the flowers.

7

Still Life Painting

Step one

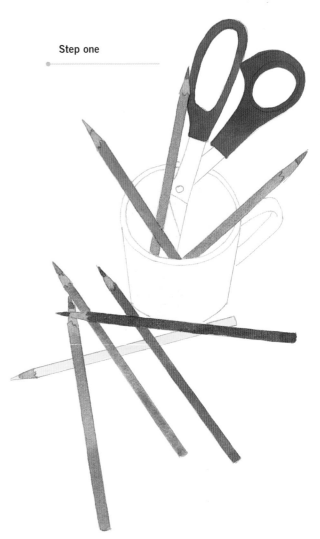

Tracing

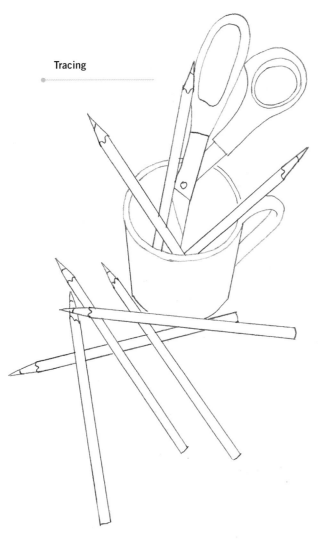

S till life paintings can be ordinary
or fabulous; it all depends on you.
Pretty baskets of flowers will
always appeal to the majority of
people. On the other hand, you can decide
to paint unusual items. In class I always ask
my students to come up with something
different. And they have. One student
painted a Chinese tray with tiny bowls and
chopsticks crisscrossing each other. It was
very colorful and a fun subject. A bowl of
nuts and bolts with tools all around is also
different. The contents of a jewelry box is

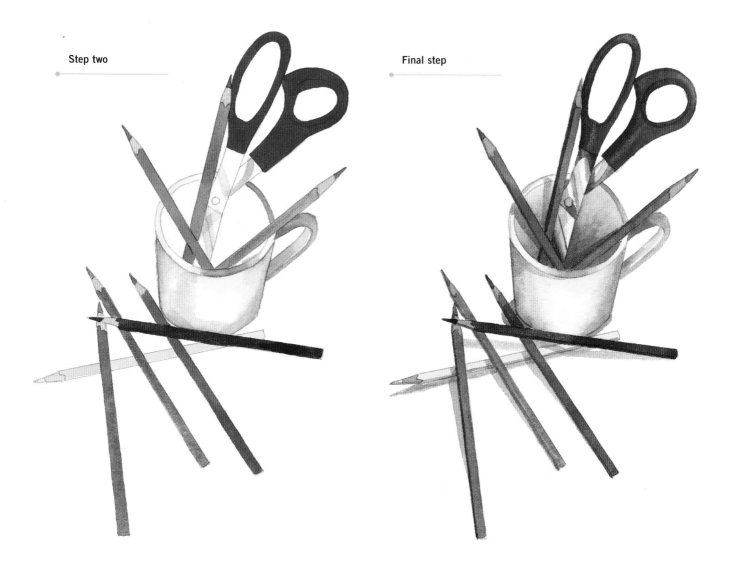

not a common subject. Try a pile of cups and saucers towered haphazardly. An old catcher's mitt with scuffed baseballs on a chair is timeless.

Mug, Scissors, and Pencils

To get the proportions correct for this still life, I took a digital photo and blew it up to the size of my watercolor paper. I then transferred it to my paper (see page 33), using a #H pencil. This is a simple subject painted on dry paper.

I then painted the solid-color areas of the colored pencils and the handle of the scissors.

After that, I added the various colors to the mug and some color to the blades of the scissors.

In the final stage, I added the shadows to the inside and outside of the mug, as well as to the pencils and the surface of the table. The finishing details on the scissors were completed last.

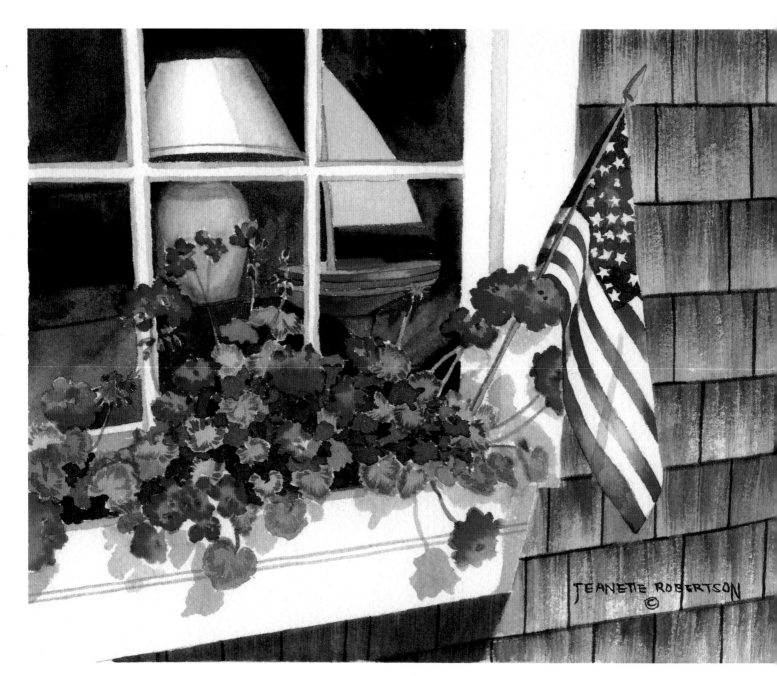

Window, flag, and flower box, showing
(A) Step one—textured shingles,
(B) Step two—negative space behind lamp,
(C) Step three—negative space behind boat,
(D) Step four—negative space behind stars,
(E) Step five—flag, and (F) Step six—flowers.
Step seven—finishing the lamp, boat, and
details—is not indicated with a letter
in the picture.

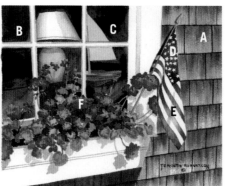

Still life with
window, flag,
and flower box

Window, Flag, and Flower Box

This still life with a window, flag, and flower box (shown left) is a bit more challenging. However, the good news is, you have used all the techniques in earlier exercises. At this point, when I say positive and negative space, shapes and shadows, wash, glaze, and texture, you know what I mean. This painting is done on dry paper.

Vignette with Flowering Teacup

This still life with an old-fashioned teacup with flowers (shown below) is a classic vignette. Note the white background and how the colors do not extend fully to the edge of the frame. To bring appropriate color temperature and harmony to this painting, different values of the same colors found in the flowers and leaves appear on the table top and in the doily as well.

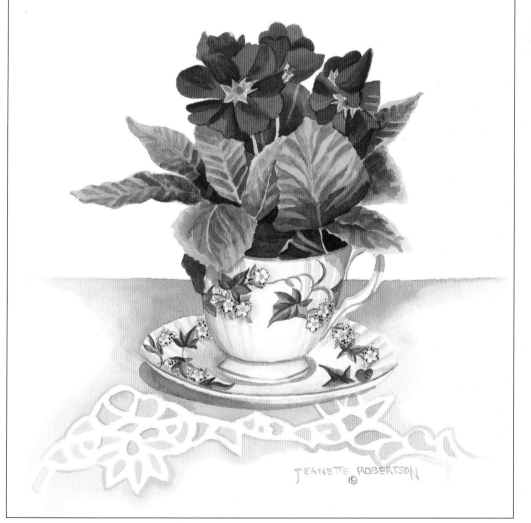

Here's an example of a vignette.

Step One

Hydrangea
foundation

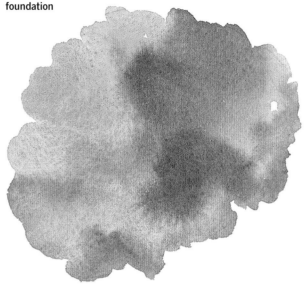

Step Two

Hydrangea with the beginning use
of negative space

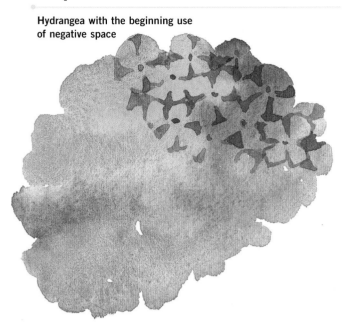

Hydrangea and Basket

Although a floral subject, the hydrangea is painted as negative space (steps one and two above). The cluster of blossoms is painted on top of a basic "ball" shape that is painted first in light values of blue and violet.

The negative space of the petals is then painted in a darker value in shades of blue and violet.

Beginners sometimes paint a cluster of flowers like the illustration at near right. As you can see, it doesn't look like a hydrangea at all.

For the finished painting on the opposite page, the leaves of the hydrangea are painted in a similar way, with the lighter base going down first and then layers of glaze details for the leaves painted on top. The basket is a repetitive design of positive and negative shapes and different values. A simple texture created with a sea

Barely recognizable hydrangea. Don't do this.

sponge is used in the background. The lace tablecloth is created with negative space in the cutwork of the lace and shadows. The entire painting is designed in the vignette style. A vignette is a painting that is not painted to all four corners of the paper. Some white of the paper is left untouched.

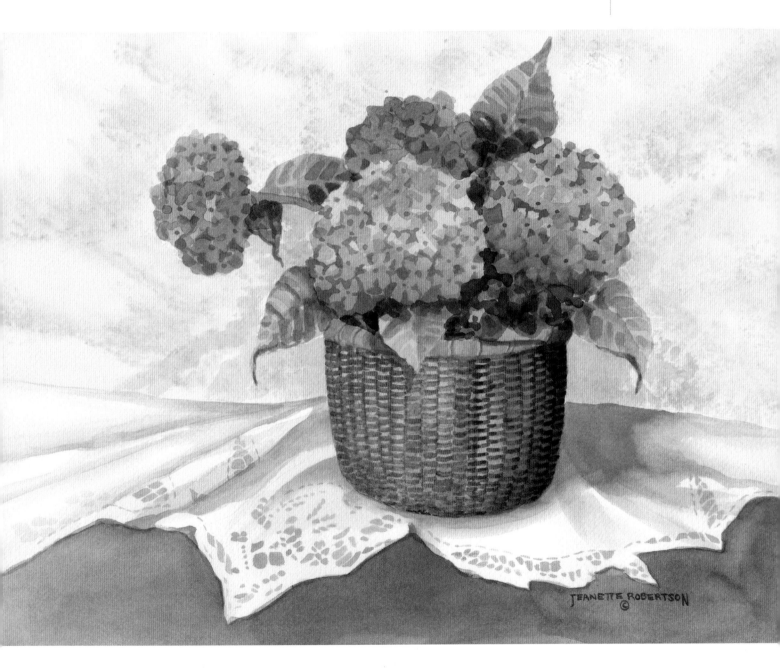

JEANETTE ROBERTSON
©

Color Sketches— Painting on Location

ainting on location can be a challenge. Dealing with the weather is the number-one problem. Heat and wind will dry your paper fast. Flying insects can land on paint and paper. Then there is the possibility of spectators. Some artists are not comfortable working with someone looking over a shoulder. For me, painting on location is just for doing color sketches but not for finished art. I like the controlled conditions of the studio for finished art.

Drawing

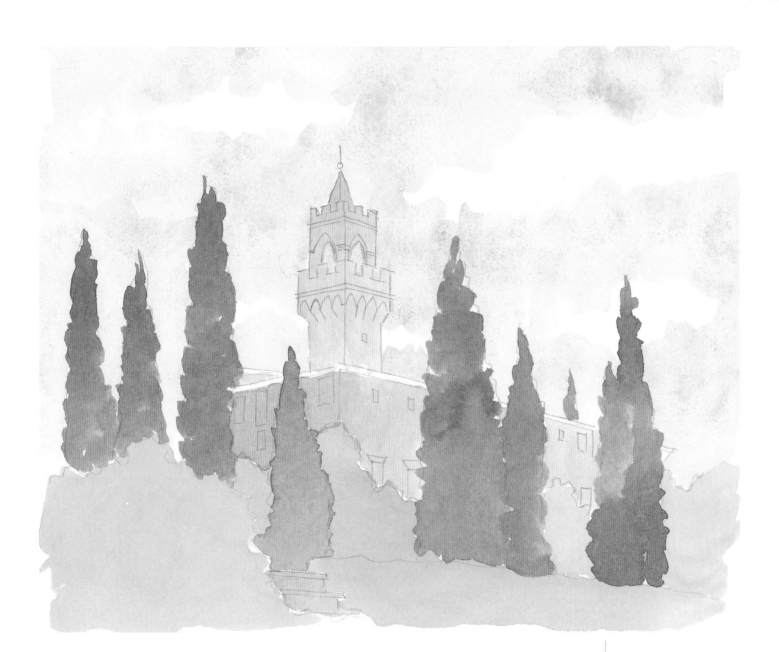

You can really get into the mood of a place when working outside. On a trip to the Tuscany region of Italy, I took hundreds of photographs. I also enjoyed setting up my equipment and painting *en plein air*.

For a week I stayed near the castle shown here. The panoramic views of Castello di Montegufoni are breathtaking. This sketch is just one side of the castle. I worked on dry paper when on location. I also used pan paint.

Castle in Tuscany Sketch

Foundation

I began with a light pencil drawing of the major subjects (see drawing at left).

First, I painted the sky, leaving hard-edged clouds. Note that working outdoors changes the way you work—hard edges are one of the results. Next, I painted the undercoat base for the trees, bushes, and castle (see above).

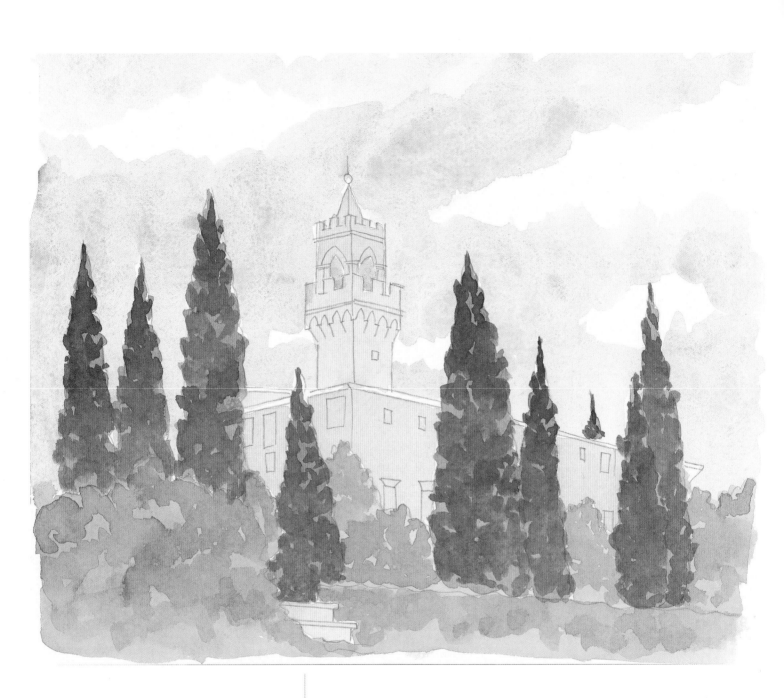

More details

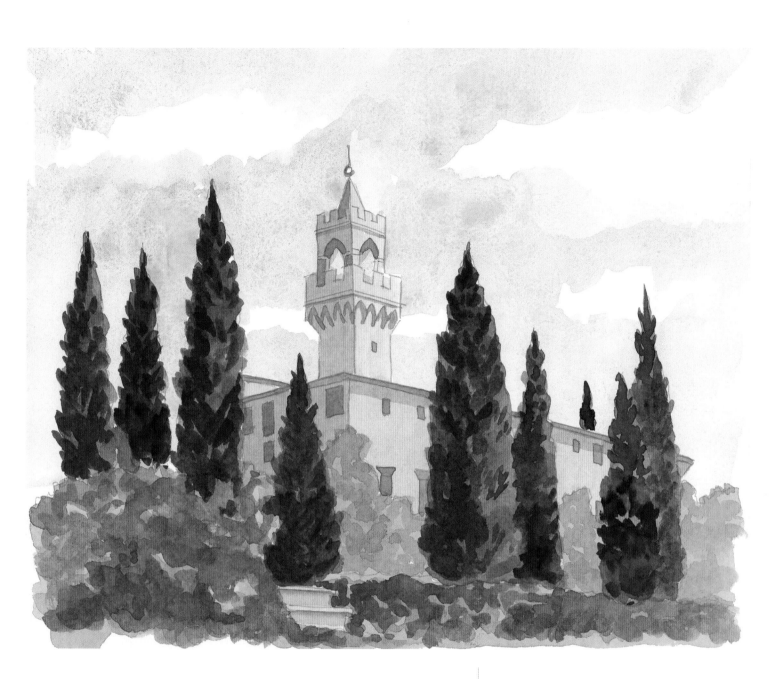

Final sketch

After setting in the undercoat, I worked on more detailed building up of colors in the trees, bushes, and castle. (See rough sketch at left.)

Last, I put more colors and details into the landscape and castle (see final sketch above).

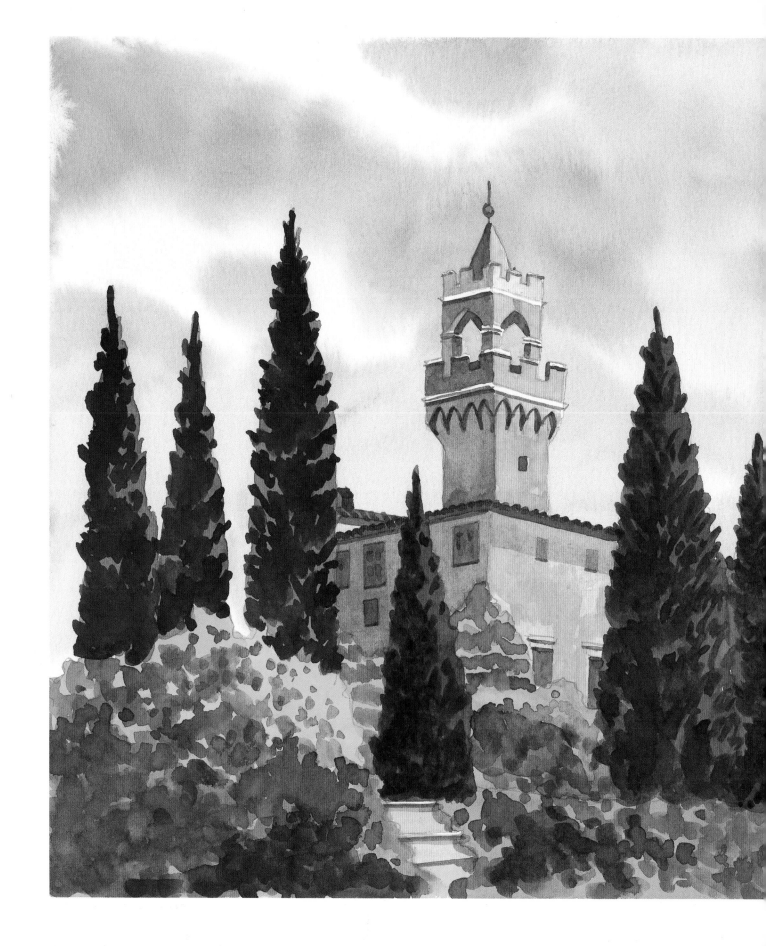

Finished Art

When in my studio, back home, I created the final painting, working from my color sketch. Notice the softer sky and clouds and the details in the landscape and castle.

Finished painting

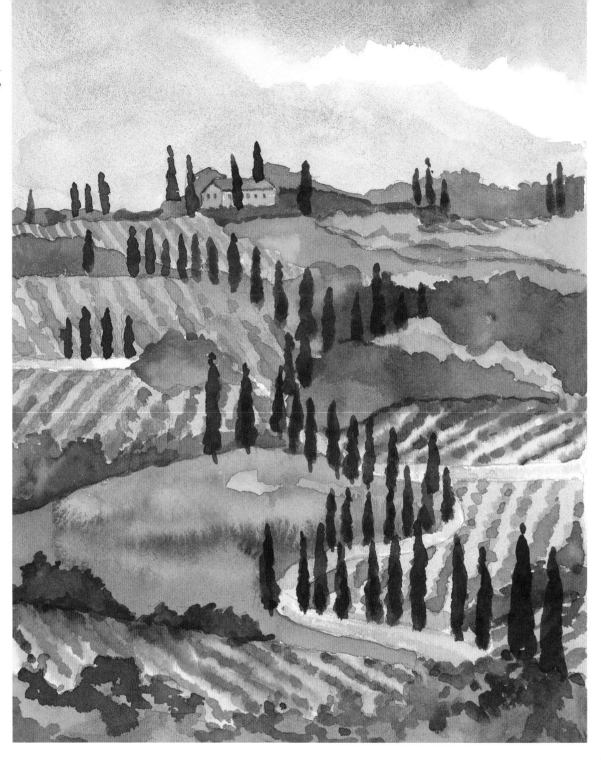

Hills of Tuscany Sketch

The castle has villas on the property. I stayed in a private villa not far from the castle. Every morning I woke up to a spectacular view of rolling hills and farms. My painting of this view shows a winding road with cypress trees, olive trees, and grapevines in the distance. The cyprus trees are dramatic in dark contrasting colors and values.

Composition and Critiques

Good and Poor Compositions

There are certain common mistakes that all beginners make, and sometimes professionals make them too. The mistakes, and methods to correct them, are described in this chapter. You will notice some advanced uses for your equipment.

There will be a number of new concepts and rules. Important information about composition will also be covered. Students have a variety of questions, some of which I will answer here. Most of these questions and answers are taken from my classroom experience, and you may find them helpful. My examples are rough sketches, not finished paintings.

Lining up art makes for an uninteresting composition.

Common Mistakes

Lining Up

Most beginners paint their still life subjects on the bottom of the paper as if the bottom of the paper were a tabletop, or paint a scenic subject as though the bottom were the ground. The painting should be planned as a composition. If you are painting a still life, then the surface that the subjects are sitting on needs to be painted—for instance, the top of a table that the subjects rest on, if you are painting a vase of flowers or bowl of fruit.

Another common mistake is having all the objects in a still life more or less the same size. When they are arranged all in a row and in a straight line, it becomes even more boring.

Try to use different-size objects with different shapes too, and arrange the objects in front of and behind each other, which is much more interesting, as in the composition on page 76.

Near to the Edge

It is also helpful to keep in mind that when a painting is matted and framed, the edges of the paper are covered by the mat. Therefore, do not paint any major subjects near any edge of the paper because they may be cut off. (See drawing below.)

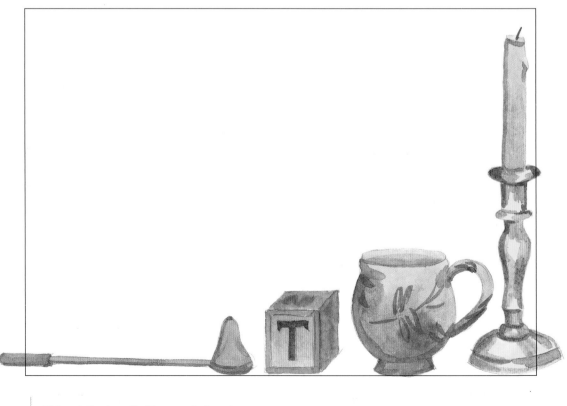

This painting is matted too near to the edge.

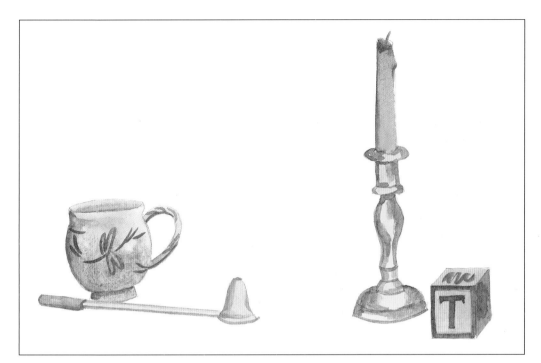

Original painting before division.

Dividing a weak composition into two good paintings

Two Paintings in One

The next problem occurs quite a bit with beginners, so don't feel bad if you make this mistake. Objects are placed to the left and right sides of the paper with nothing going on in the middle. Sometimes this can be fixed simply by adding some objects that would fill up the middle field and connecting the left to the right. Sometimes it cannot be fixed.

But take heart—the painting could end up being two paintings. Just cut the paper in half, and you may have two good paintings. (See original and the two new paintings on this page.)

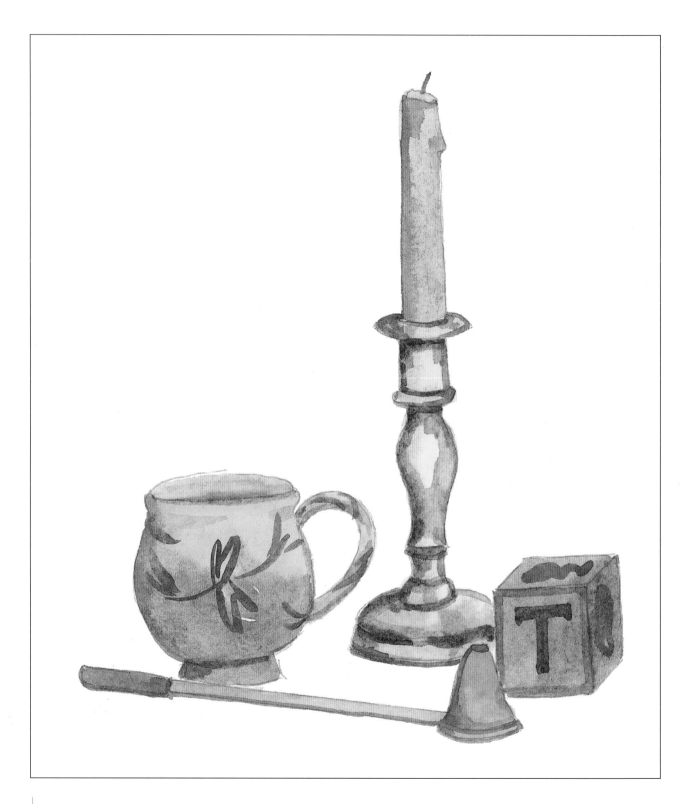

Interesting composition, rough sketch

Triangles

When you really start looking at art, you may discover some very pronounced triangular shapes within the compositions. Very strong triangular shapes can be seen in the following two examples. This is one way to create a good composition. Winslow Homer is one of my favorite artists, and he uses strong triangular shapes in his paintings. You can find books of his art at your library.

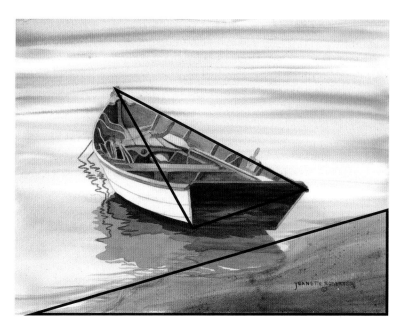

Rowboat composition with triangles

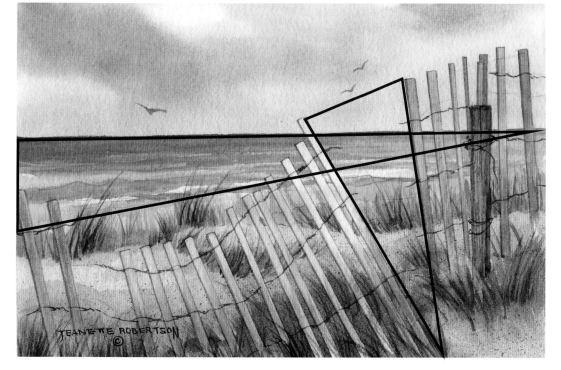

Beach composition with triangles

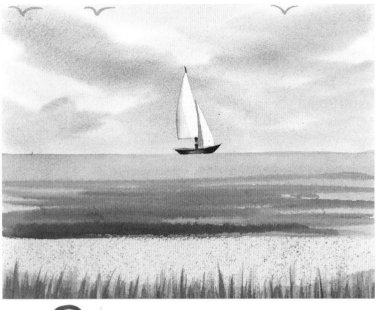

 Uninteresting composition, rough sketch

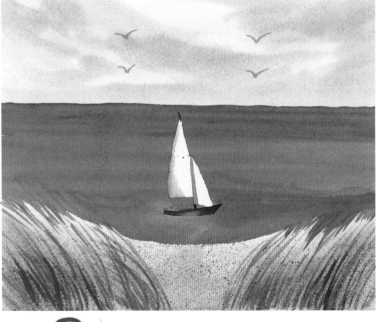

 Uninteresting composition, rough sketch

Horizon Line, Centering, Even Numbers, Directing the Viewer's Eye

A frequent mistake beginners make is having a horizon line that is not broken at any point by an object. They also often place the main subject right in the middle of the painting.

Another common mistake is using even numbers of objects. If you are painting seagulls or any other subject, you can have one, two, or three of them. After the third subject, stay with odd numbers: five, seven, nine, etc. Also avoid having objects that point out of the painting.

Beginners often place a subject on top of a horizon; this should be avoided too. It is also not a good idea to have bands of unbroken horizontal or vertical placements. Here are two rough color sketches that demonstrate some of these errors. (See paintings at left.)

The next rough color sketch (see painting at right) is more interesting and a better composition. The center of attention in this sketch is the sailboat. In most paintings, the darkest dark value next to the lightest light value will be your center of attention.

Sometimes the center of attention can be created with a contrasting color—for example, a red glove in white snow. Either way, your eye will be drawn to it. So keep this in mind when you want an object to be your center of attention.

A Few More Points

Make sure that other objects do not draw the viewer's eye away from the subject. If grass appears to be blowing out of the painting, the viewer's eye will follow. Have the grass blow toward the subject, directing the eye inside the painting and continuing around the subject.

If both sides are equal in mass, correct this by making the left and right sides of the painting uneven. This adds visual interest.

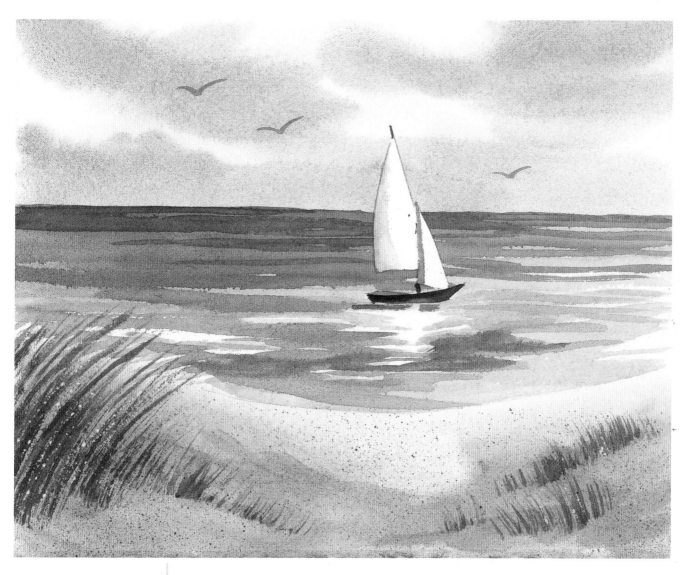

Better composition, rough sketch

 First sketch

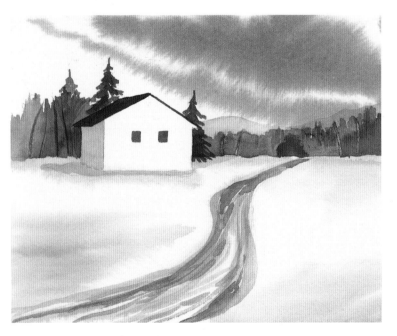

Improved version, rough sketch

Avoid Straight Lines and Use Negative Space

Straight lines can be quite boring. Even if a road is straight, as an artist, you can make the road curve and have shape and interest. The "S" shape is sort of a rule in composition. Look at the two rough sketches on the left. See how the curving road in the second sketch is a big improvement over the straight road in the first version. Also, notice that in the first sketch, the color from the sky (color temperature) is not repeated in the foreground (as it should be), thereby cutting the painting in half.

The negative space in the good version defines the building. In the poor sketch, there is an outline around the building.

When painting trees in the distance, make sure there are value changes; you can have color changes as well. This will keep your painting interesting and prevent it from being flat.

Adding Sparkle

Sometimes paintings get dull and need just a little sparkle or an accent to give them a lift. There are different ways that this can be accomplished. Here are six rough sketches of the most common solutions applied to a body of water. These solutions can be applied to other subjects as well.

The lighthouse sketches show (see opposite page) the results of scratching the surface of the paper with a knife when the paint is dry, using liquid mask, using sandpaper to remove paint when it is dry, applying white gouache paint on dry paint, removing paint using masking tape when the paper is dry, and using kosher salt on wet paint.

Accenting a Painting Using Different Techniques, Rough Sketches

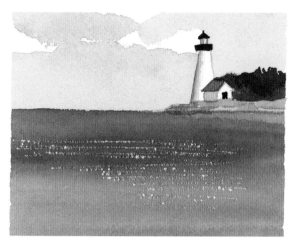

Scratching the paper

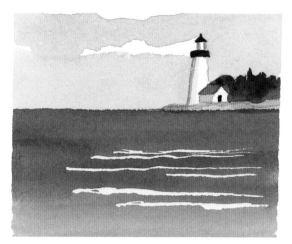

Using liquid mask

Removing paint using sandpaper

Using white gouache

Removing paint with masking tape

Applying salt

Avoiding Common Mistakes

There are certain mistakes that happen all the time, even with professional artists. It is good to know how to identify them ahead of time.

Line of Trees on Hilltop

Lining up trees like little toy soldiers all the same size and distance apart looks quite monotonous. But this can be remedied easily. By adding a variety of sizes and spacing, as well as shapes, you create a more varied and engaging composition. (See the two examples below.)

Monotonous composition, rough sketch

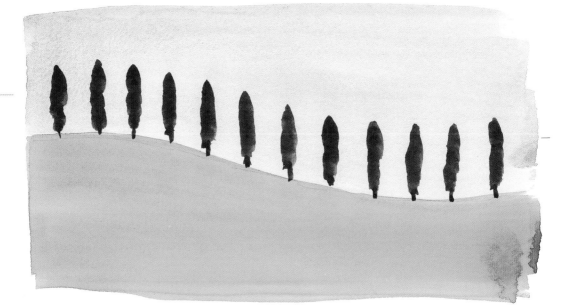

More interesting composition, rough sketch

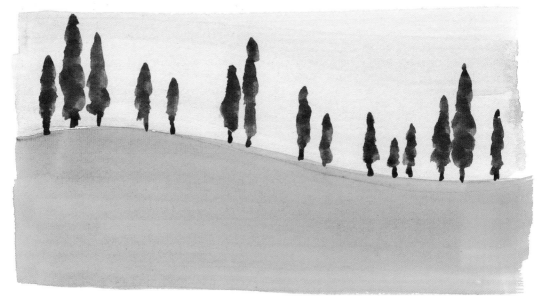

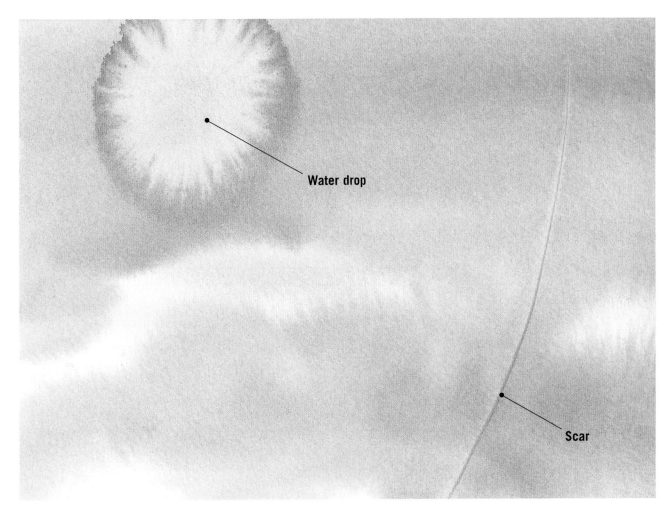

Water drop

Scar

What Happened Here?

Sometimes little weird things pop up on your finished painting and you have no idea how they got there. Here are the most common culprits.

Drop of Water

You may have dropped some water onto your painting while it was still wet, causing a back run, or *bloom*. Be careful not to splash around too hard in your water when cleaning your brushes, to keep any drops from falling onto the painting. (See top left "bloom" on image above.)

Scar Line

While you were getting your paper wet in the sink, you might have run your fingernail across the paper. Or you may have scarred the paper with a sharp object. Handle the paper with care when it is wet or dry. (See vertical scar down right side of image above.)

Common occurrences— drop of water and scarring

Paper too wet, rough sketch

Paper Too Wet

If your paper is too wet, you will have paint run into areas that need to be sharp or crisp. If you are adding grass or tree branches or a horizon, first make sure your paper is either damp or dry, not wet.

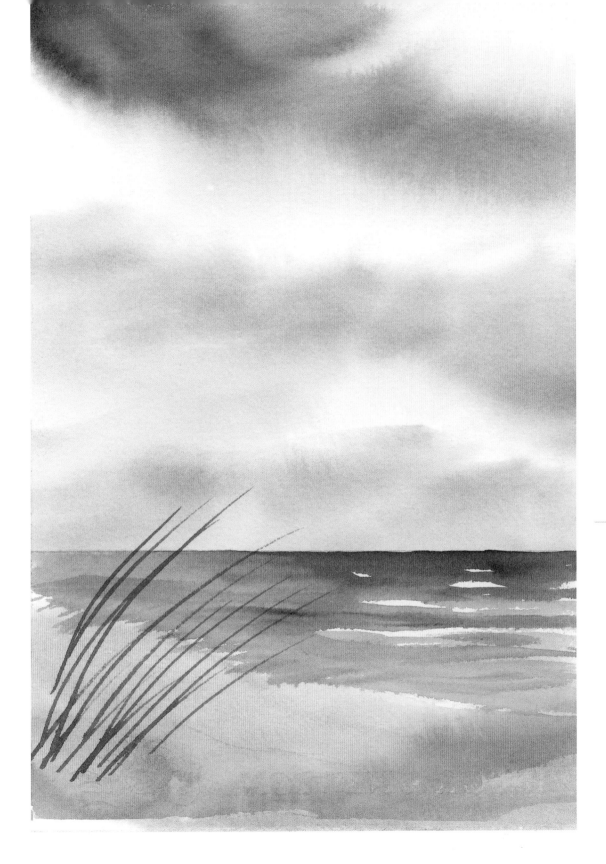

**Drier paper,
rough sketch**

Hand Lotion Prints

If you have hand lotion on your hands or you just ate a delicious piece of pizza that was dripping in oil, be careful—oil and water do not mix, and you will get fingerprints on your paper.

Cropping

Planning ahead for your painting is important. Use paper to the scale of your art, or make your art to scale with your paper—either way. In the painting on the top of page 87, leaves are taking up a very small area of the paper. Rather than destroy the art, or frame the art as is (which is a poor composition), you can crop the art. Beginners and professionals do this all the time, so don't be hard on yourself. You don't need to fill up the area of the paper with texture or color simply for its own sake. You can just crop the paper and then mat and frame the main subject—in this case, the leaves.

Fingerprints, rough sketch

Full size, rough sketch

Cropped, rough sketch

Window Template

This is a neat little item you can make yourself out of white cardstock. Use the back of an old greeting card. Cut a rectangular hole in the middle of the cardstock about 1 inch × 3/8 inch (2.5 × 1 cm). You can then use it to lay over colors on your painting to see if you like the color. It will segregate the color by not having other colors around it, thereby not affecting the color you really want to see. It also helps when you want to mix and test a color before using it on your painting.

Window template helps isolate a color in this rough sketch

Gallery

We've finished the basics of beginners' watercolor painting techniques. At this point, you are well equipped to work on your own. If you are unsure about any of the exercises or paintings that you did, you can always go back and refer to this book. Some of my students have benefited by taking the beginners' course over again. After they have gotten over their initial fears, they progress quite well.

All of the paintings in this gallery are made on a quarter sheet of watercolor paper (11 inches × 15 inches or 28 × 38 cm). I hope you enjoy them and they inspire you. Good luck and good painting.

Lilacs

Lilacs are one of my favorite blooms to have in the house. I love their fragrance, especially while painting them. For the painting *Lilacs* shown here, first I lightly drew with a pencil where I wanted the heads of the flowers to go. Then I lightly drew in the leaves and stems as well, along with the vase. Working on wet paper, I quickly put in some background color and then applied the basic colors for the floral cluster. The floral cluster area is just like that in the hydrangea painting found on page 64. When it dried, I painted the negative space of the tiny flowers in each cluster. The leaves and stems went in next. The shadowing and shaping of the vase came last. (See page vi for a larger version.)

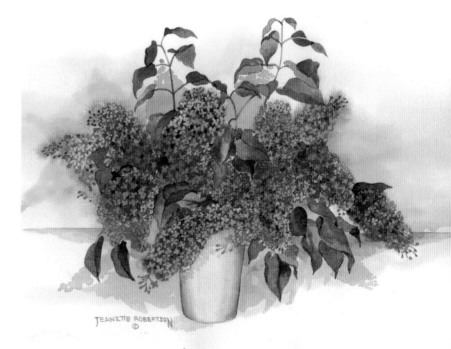

Lilacs

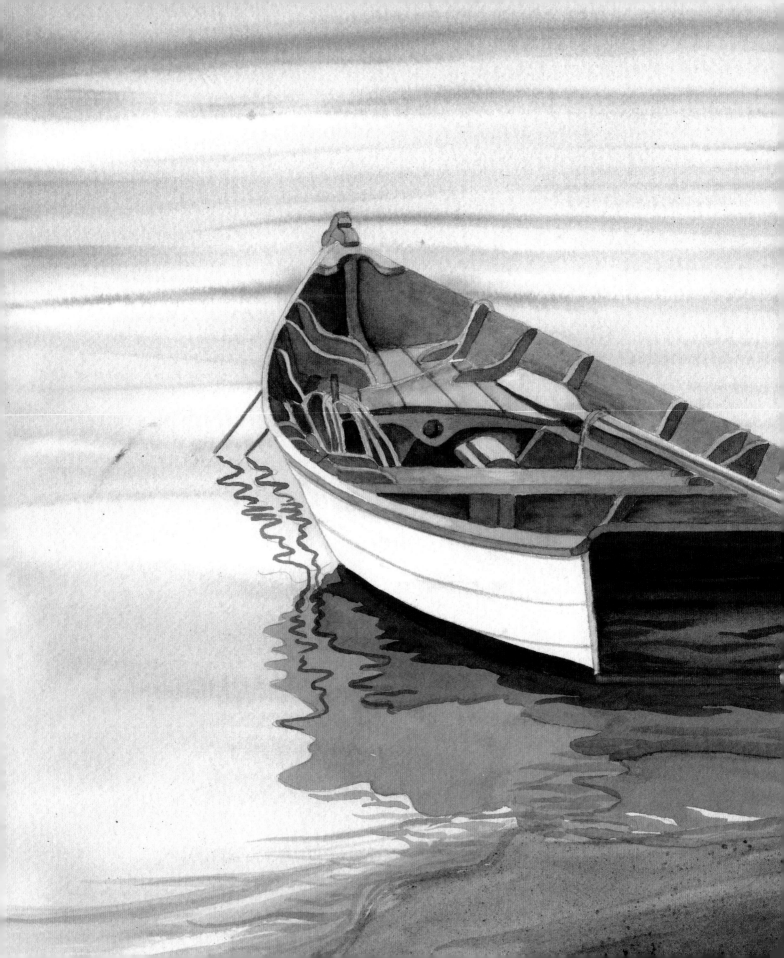

Beached Boat

Beached Boat is my favorite painting.
The soft colors in the water create a
mood of quiet and peace. The inside
and back of the boat were painted with
many glazes. I used liquid mask on the
boat so that I could be free to paint the
water and beach without contaminating
the boat area. The water and sand were
painted wet and the boat dry.

Beached Boat

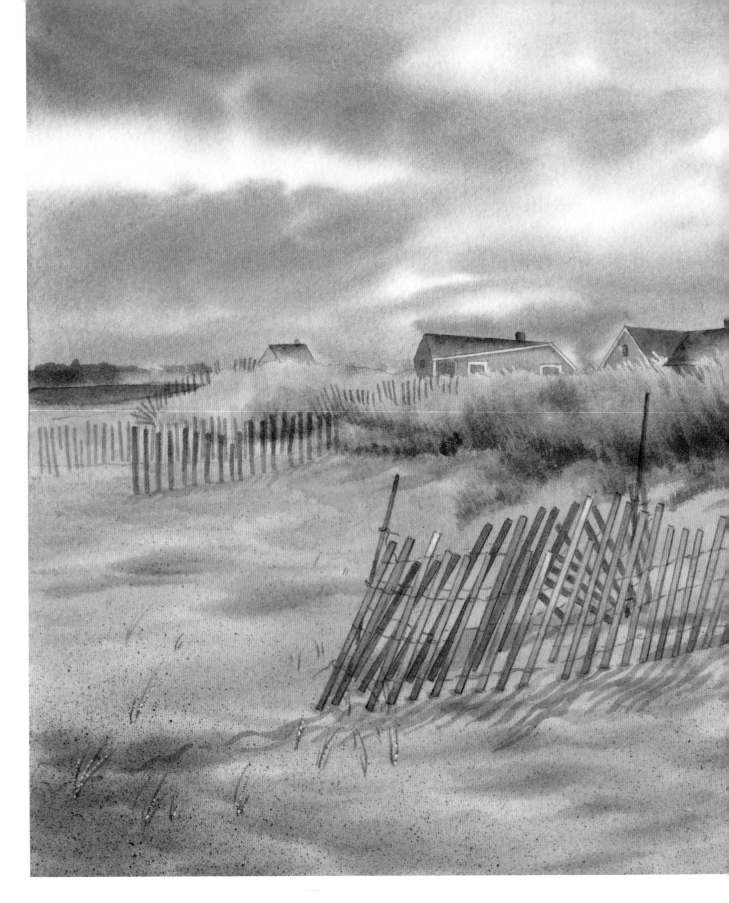

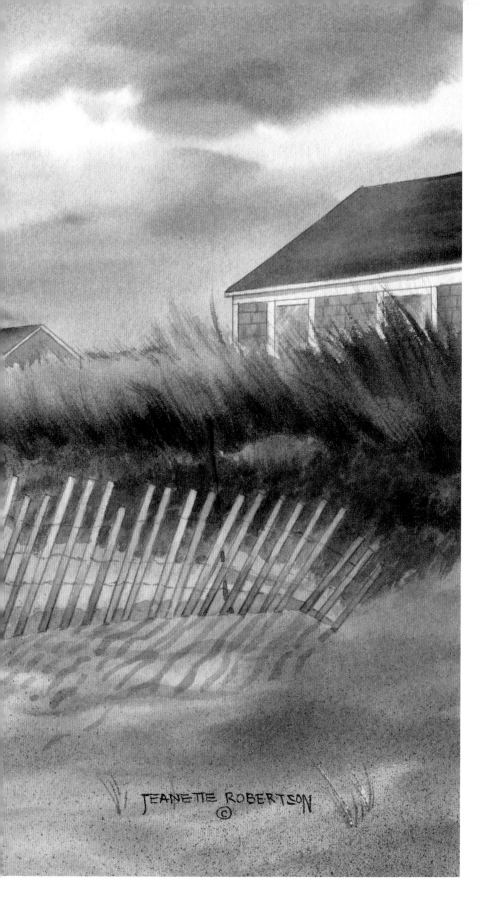

Beach Walk

The painting *Beach Walk* is one of my favorite scenes. It's found along a beach that I walk on when I am visiting Cape Cod. It is in Brewster and on the mud flats. I walk on it at least an hour a day.

The 60-second sky was painted first. While the paper was still wet, I put in the sand area and the shadows on the sand. The grassy area was painted next. At this point, the paper was damp and I could get more details in the grass. Once the paper was completely dry, I painted in the fence, buildings, and stipple on the sand. Note how the windows reflect the blue of the sky.

Beach Walk

Gazebo

This gazebo is in Skaneateles, New York. Skaneateles Lake is one of the Finger Lakes. I wanted to record the charm of the old village by painting the gazebo in the park. First, the 60-second sky was painted on wet paper. The green in the foreground was laid out next. Then I waited for the paper to dry. When the paper was slightly damp, I laid in a little of the background. I worked on the rest of the painting when the paper was completely dry, giving special care and attention to the texture details. In this painting, I especially like the analogous color relationship between the blues and greens.

Gazebo

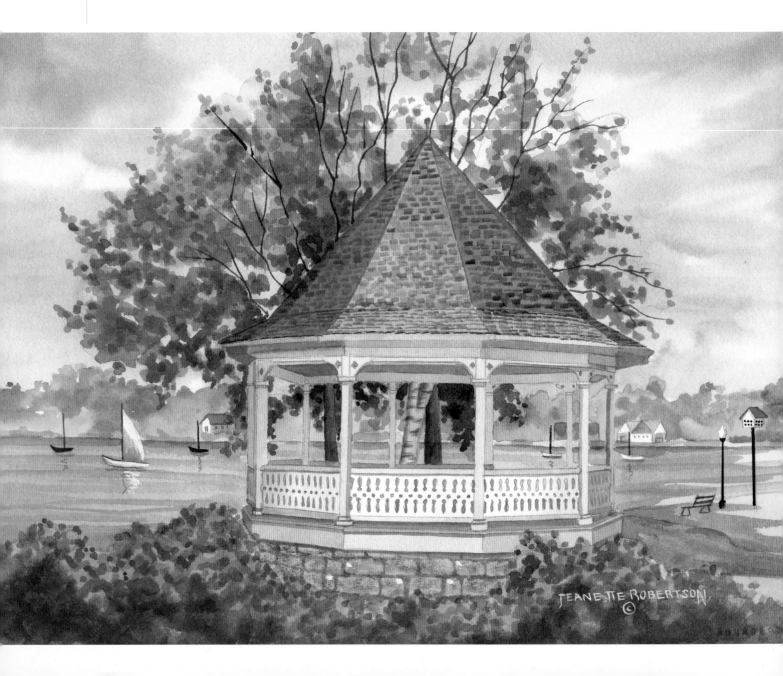

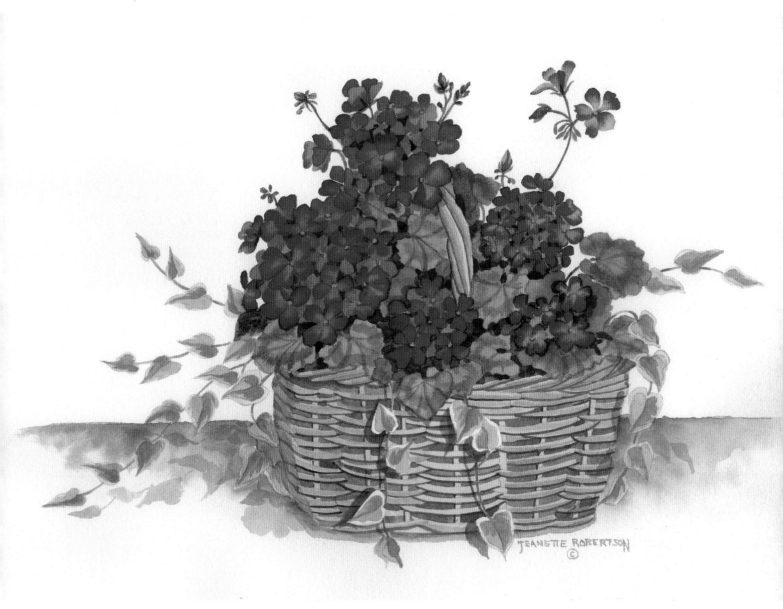

Geranium in a Basket

The painting *Geranium in a Basket* was begun in class as one of my demos. I finished it at home. Using a #H pencil, I drew the overall shape of the cluster of flowers. Next I added the leaves and stems. Then I drew the weave of the basket, aware that it too is painted in negative space. The vine types of leaves had liquid mask applied to them to protect the area. I worked on dry paper,

wetting just each section at a time with a blending method described in the exercise on pages 16–17. The basket was completely painted in a light wash of Yellow Ochre and a little Raw Umber. The weave was created by the dark brown negative space inside the basket. The red flowers were done using the negative space method. Finally, I removed the liquid mask from the vine, and completed the leaves along with a little shadowing.

Daylilies

Here's a fun technique I used when painting *Daylilies*. At the end of my classes, if we have time, I give my students a fun assignment. I tell them, first use liquid mask where you want the flowers to be painted. That will protect the area so that you can paint the orange flowers (or whatever you choose) later. Next soak the paper in water. Working very quickly, apply yellows and greens all over the paper. While it is still very wet, place a crumpled-up plastic bag over the paper and then cover the entire surface with a board. On top of the board, stack a big book or two for added weight. Let this sit a few hours or overnight. When you remove the plastic bag, an intriguing texture remains. Then begin work on the leaves. After the paint dries completely, remove the liquid mask and paint the flowers.

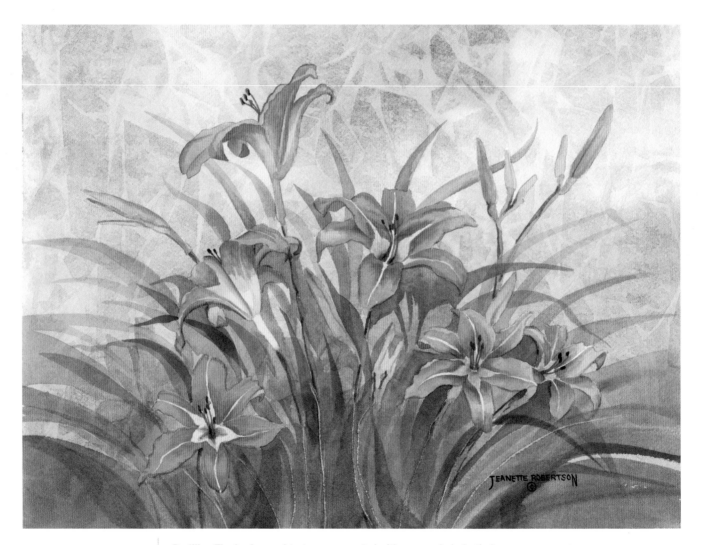

Daylilies. The background texture was created with a crumpled plastic bag.

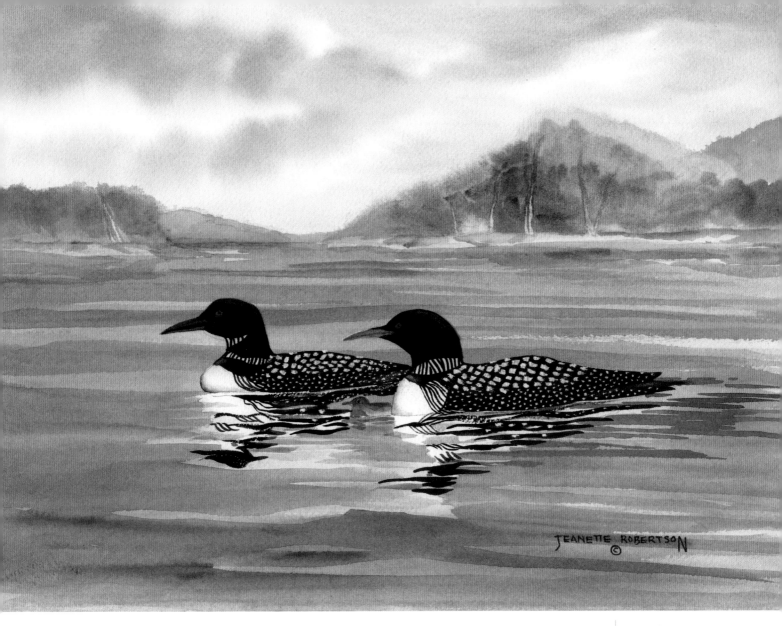

Loons

I am fortunate to live not too far from the Adirondacks. Most people do not realize that one third of the entire state of New York is the Adirondack Park, and it is magnificent. There are a lot of open spaces. Wildlife is abundant. On one of the many lakes is a family of loons.

Before starting to paint, I put liquid mask where I had drawn the loons on the paper. I painted the 60-second sky first. I laid in a light undercoat for the water after that. Then, while the paper was still damp, I put in the background distant woods. Once the paper was dry, I removed the liquid mask and painted in the loons. I also laid in a little ripple action in the water.

Guide Boat

The guide boat was popular among the Adirondack guides in the 1800s and early 1900s. The waters are abundant with fish too. I painted this fisherman out for the day in the painting titled *Guide Boat*. Craftsmen are still building these boats by hand.

I first used liquid mask in the places where I would later paint the boat, man, and dead pine trees. On wet paper, I painted the 60-second sky. Working quickly, I laid in the undercoat foreground water and the thicket of trees. Once the paper was dry, I removed the liquid mask and painted the boat, man, and trees, as well as the mountain and ground. A little more color and value were added to the water. The blue water and the light Burnt Sienna boat offset each other well, because the colors are complementary.

Guide Boat

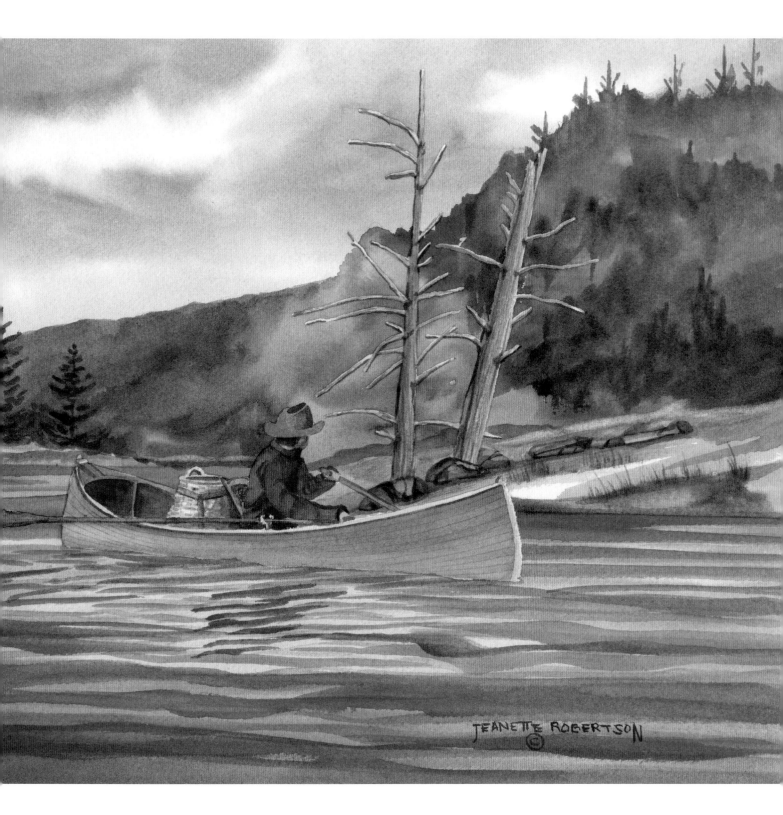

JEANETTE ROBERTSON
©

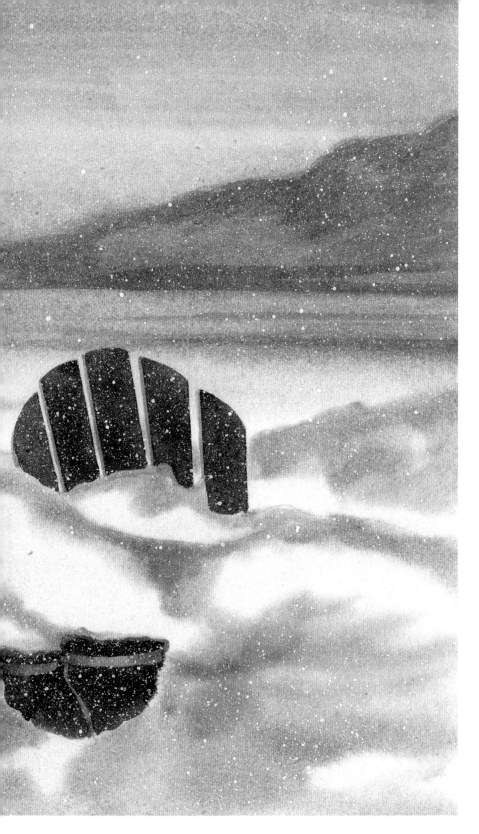

Adirondack Chairs in Snow

Here we are again in the Adirondacks in the wintertime. These chairs belong to my friend Cornelia, and I found them just as they are. The mood of winter is set here by the snow, but I also like the analogous color relationship of the blues and blue-green of the chairs. The entire snow area is painted on wet paper. I let the paper dry completely and then painted in the chairs. You do not need to use liquid mask here, because the chairs are darker than the light blue of the late-afternoon snow. Once the chairs were painted, I used white gouache and the stipple technique to apply the light snow. I could have also sprinkled on kosher salt while the paint was still wet.

Chairs in Snow

Game

Test your understanding of terms and techniques. Match up the items in the first list with the answers in the list that follows.

QUESTIONS

1 Use this brush to paint branches on trees and bushes.

2 Use this brush to paint wood texture.

3 A warm color.

4 A cool color.

5 Positive and _____ space.

6 Protects white areas of painting.

7 Layers of dry colors.

8 A spot that is created by too much water.

9 Use _____ to make snowflakes.

10 Stipple can be made with a _____.

11 Sky can be painted in _____.

12 Use this brush to make large washes.

13 A painting in one color.

14 What would you use to move wet color?

15 Color can never be removed from the paper.

16 Makes wonderful leaves on trees.

ANSWERS

A Back run

B Blue

C Fan

D Glaze

E Kosher salt

F Liquid mask

G Monochromatic

H Negative

I Not true

J 1-inch flat

K Red

L Rigger

M Sea sponge

N 60 seconds

O Spatula

P Toothbrush

CHECK YOUR ANSWERS HERE

1-L, 2-C, 3-K, 4-B, 5-H, 6-F, 7-D, 8-A, 9-E, 10-P, 11-N, 12-J, 13-G, 14-O, 15-I, 16-M

aquarelle A term originating in mid–19th century France for a drawing in transparent watercolor.

back run Also called a *bloom*. When a fuzzy line is created as a result of a wet area of paint going into a damp area of paint.

bleed When one color runs into another and makes a mess because, the first area was not dry, similar to a back run or bloom.

blending Using your brush to stroke a color so that it lightens or mixes with another color.

cold-pressed paper Watercolor paper that has a texture or "tooth" on its surface.

color sketch Any quick rough color painting not intended as a finished work. Artists often make these while working on location as a guide for one or more paintings later finished in the studio.

complement or complementary color(s) These colors are opposite on a color wheel. Examples of pairs of complements are red and green, yellow and purple, and blue and orange.

composition The layout of subjects in a painting. To work well, the subjects need to be harmonious, balanced, and have pleasant relationships with each other.

cool colors These are found on the side of the color wheel that has blue and green colors. This also refers to colors that have a cool or slightly blue undertone.

dragging When paint is still quite wet on the wet paper, the paint can be moved or dragged with a plastic spatula, credit card, or other tool.

dry brush A brush that has very little wet paint on it and that's applied to dry paper.

earth colors Colors associated with rocks, soils, sands, and clays, such as siennas, browns, rusts, and tans.

elements of design Different considerations make up the elements of design. They are: form, texture, line, color, composition, and negative and positive space.

emotion Some paintings evoke emotional responses from the viewer. This is not always easy to accomplish. The subjects can be people, animals, a storm, cheery flowers, etc. Just before 9/11, I made eight paintings with American flags in them. After 9/11 they quickly sold out.

fan brush An artist's brush ideal for making textures of wood grain and grasses. The brush looks like a fan.

flat brush The hairs of this brush are arranged flat and used mostly for washes and large areas.

focal point Also called the center of attention. This refers to the object or subject that most draws the eye in a composition. It serves as the main or central (though not necessarily "centered") object of focus of the painting.

fugitive colors Certain paint colors that fade over a short period of time, usually when exposed to sun or fluorescent lights.

glaze Laying a paint color on top of another color after the first color is dry.

gouache An opaque and semi-opaque watercolor paint.

graded wash When a color wash is applied to the paper with large strokes that become lighter or darker from one end to the other.

#H pencil A hard lead pencil that will not wash off or smudge when painted over.

hot-pressed paper A smooth-surfaced watercolor paper. This paper is ideal for illustration and botanical art.

hue This is another word for color.

intensity The vibrancy and brilliance of a color. Adding a little complementary color will dull a vibrant color.

layering This is another term for glazing.

liner brush Another name for a rigger brush.

liquid mask A fluid used to maintain the original white of the paper while the artist applies paint directly over the area.

loaded brush A brush that is holding as much water and paint as it can—before it starts to drip.

masking The process of using a liquid mask or masking tape to protect an area which will be painted over later.

masking tape Masking tape can be used in the same way a liquid mask is used. It may need to be trimmed to fit a desired shape.

monochromatic Using one color in different values. *Mono,* meaning "one"; *chroma,* meaning "color."

negative space Colors or objects behind a subject that create the shape of the subject.

palette A tray, usually made of metal or plastic, with several wells to hold watercolor paints (whether paints squeezed from a tub or in dry pans).

pan paint Dry watercolor paint usually sold in a palette.

positive space An object that is painted without the need for a background.

primary colors Red, yellow, and blue. These colors can be mixed to make all other colors.

receding color(s) Cool colors aid in making a subject appear to recede from view.

removal Lifting off paint from the paper.

rigger brush An artist's paintbrush with long hairs. This brush is ideal for painting grasses and branches; it also holds a lot of paint for a long time. It is often called a *liner brush.*

round brush The hairs of this paintbrush are arranged in a round shape.

sea sponge A highly textured natural sponge from the sea, useful for creating texture in paintings. (Avoid using synthetic, manmade sponges on artwork.)

secondary colors These colors—orange green, and purple—are created from mixing two primary colors. Red + yellow = orange; yellow + blue = green; red + blue = purple.

spatula A handy kitchen device that is used to move and remove paint on a wet painting. It's best to use a rubber or flexible plastic spatula.

stipple A fine dotted texture that is created with the use of a toothbrush and knife by stroking a toothbrush loaded with paint, over the flat top of a knife. Stroke the brush away from you and toward the paper (or else you will get splattered with paint). This is sometimes called *splattering.*

temperature Colors have a temperature. Red is hot, blue is cool.

tertiary colors Colors that combine primary and secondary colors are yellow-orange, blue-green, red-violet, and so on.

toothbrush The common toothbrush makes a useful tool for creating a stippled texture.

tube paint Watercolor paint that is soft and comes in a tube.

value Relative lightness or darkness of a color and everything in between.

warm colors These colors are on the side of a color wheel that has red and yellow.

wash Large strokes of paint that are usually done with a large, flat brush.

watercolor paper This paper is usually sold in 22 × 30-inch (56 × 76-cm) sizes. Artists typically use a quarter sheet measuring 11 × 15 inches (28 × 38 cm) for a painting. The paper weight is given in grams per square meter. Three varieties are hot-press, which tends to be smooth, cold-press, which has more texture, and rough textured paper, which can create a grainy effect.

wet-on-dry Adding wet color on dry paper.

wet-on-wet Adding wet color onto a wet paper.

window template A paper template device that aids in isolating or segregating a single color in a composition. The window template is helpful when you want to match a color when remixing.

METRIC EQUIVALENTS
1 inch = 2.54 cm = 25.4 mm
½ inch = 1.26 cm = 12.6 mm

Index

About the Author

Jeanette Robertson has been painting watercolors since childhood. Her family and schoolteachers saw promise in her work. Over the years, she has won many awards, but she says what is most gratifying for her is when people tell her, "This painting gives me such a feeling of peace."

Her degree from the Fashion Institute of Technology is in textile design, and she worked in that field in New York City. In 1991 she left her home on Long Island and moved to a small town in upstate New York, where she pursued her painting. Right away she started selling her artwork to greeting card companies. She also sells her work in shows.

Jeanette teaches watercolor painting classes near her home and has given workshops at the Norman Rockwell Museum in Stockbridge, Massachusetts; the Academy Art Museum in Easton, Maryland; and for various organizations. Her art and writing have been published in magazines as well as in the *Christian Science Monitor*. She lives with her husband and golden retriever.

To arrange workshops, you can contact Jeanette by e-mail: JRwatercolors@aol.com

For buying selected paintings, visit her Web site: www.cottageartstudio.com